LEGENDARY L

— OF —

THE ANTELOPE VALLEY

CALIFORNIA

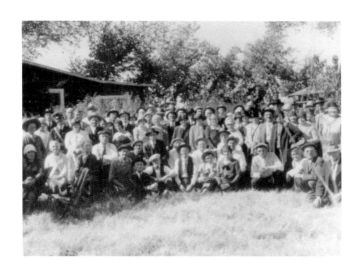

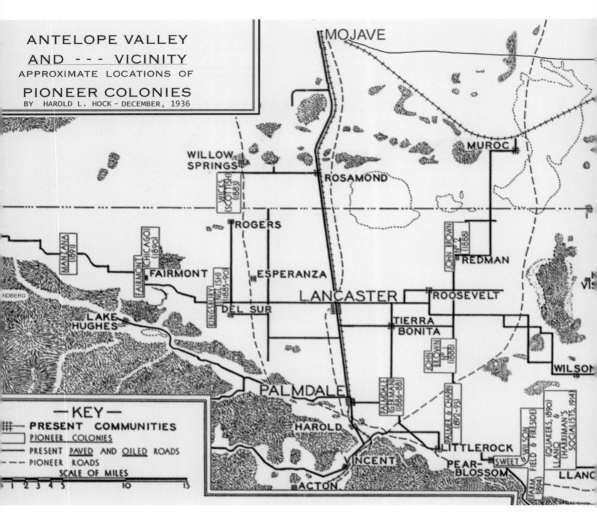

ANTELOPE VALLEY
AND - - - VICINITY
APPROXIMATE LOCATIONS OF
PIONEER COLONIES
BY HAROLD L. HOCK - DECEMBER, 1936

MOJAVE

MUROC

WILLOW
SPRINGS

ROSAMOND

VICKS
(SCOTTISH)
(1883)

ROGERS

MANZANA
(1891)

CHICAGO
(1890)

FAIRMONT

FAIRMONT

ESPERANZA

JOHN BROWN
N-2
(1888)

REDMAN

NDBERG

KINGSBURY (1SH)
STENGEL (1885-90)

DEL SUR

LANCASTER

ROOSEVELT

VIS

LAKE
HUGHES

TIERRA
BONITA

JOHN
BROWN
N-1
(1888)

WILSON

PALMDALE

PALMDALE
(GERMAN)
(1886-88)

PALMER & CHAPIN
(1872-93)

WILSON

PALM
FIELD 6 FIRESIDE

LLANO
(QUAKERS, 1890)
&
(HARRIMAN'S
SOCIALISTS, 1914)

—KEY—
PRESENT COMMUNITIES
PIONEER COLONIES
PRESENT PAVED AND OILED ROADS
PIONEER ROADS
SCALE OF MILES
1 2 3 4 5 10 15

HAROLD

LITTLEROCK

VINCENT

PEAR-
BLOSSOM

SWEET

PALM
(1894)

LLANO

ACTON

Map of Antelope Valley Pioneer Communities
This map depicts present-day and former Antelope Valley pioneer communities. (Courtesy of West
Antelope Valley Historical Society.)

Page 1: Early Pioneers
Some of the Antelope Valley's earliest pioneers are shown attending the annual Old Timers Reunion in
1922. (Courtesy of West Antelope Valley Historical Society.)

LEGENDARY LOCALS
OF
THE ANTELOPE VALLEY

CALIFORNIA

NORMA GURBA

Norma Gurba

LEGENDARY
LOCALS

Legendary Locals is an imprint of Arcadia Publishing
Charleston, South Carolina

Printed in the United States of America

Library of Congress Control Number: 2013930898

For all general information, please contact Arcadia Publishing:
Telephone 843-853-2070
Fax 843-853-0044
E-mail sales@arcadiapublishing.com
For customer service and orders:
Toll-Free 1-888-313-2665

Visit us on the Internet at www.arcadiapublishing.com

Dedication
This book is respectfully dedicated to the many pioneers and residents who make the Antelope Valley what it is today, and for future generations.

On the Front Cover: Clockwise from top left:
Donie B. Shumake (left), Antelope Valley Fair director (Courtesy of Lancaster Museum of Art and History; see page 46), Clifford and Effie Corum, founders of Muroc (Courtesy of Lancaster Museum of Art and History; see page 12), Sandy Corrales-Eneix, community volunteer (Courtesy of Ruby Alvarado and Sandy Corrales-Eneix; see page 68), Marcus Fernando Andrade, constable (Courtesy of Anaheim Public Library; see page 32), Carl Bergman, National Hall of Famer of the Early Day Gas Engine and Tractor Association (Courtesy of the City of Lancaster Museum of Art and History; see page 101), Eben Merrill Skillings (left), miner (Courtesy of the City of Lancaster Museum of Art and History; see page 47), Murl Genrich (left), store owner (Courtesy of the City of Lancaster Museum of Art and History; see page 110), Nellie Almeda Frakes Thompson, pioneer (Courtesy of Donna and William Kahler; see page 12), Ulysses Chatman Jr., educator (Courtesy of Ulysses Chatman Jr.; see page 67).

On the Back Cover: From left to right:
Anna Clark Davis, librarian (Courtesy of Lancaster Museum of Art and History; see page 80), the Fuller family, farmers (Courtesy of Lancaster Museum of Art and History; see page 30).

CONTENTS

ACKNOWLEDGMENTS

The author and the staff of the City of Lancaster Museum of Art and History (LMOAH) wish to sincerely thank the following people, organizations, and businesses that supported our efforts in preserving the Antelope Valley's rich pioneer heritage: Tiffany Frary; Mary Almandoz; Lou Alred; Anaheim Heritage Center at the MUZEO; Anaheim Public Library; Antelope Valley College; Antelope Valley Conservancy, AVTREC; Antelope Valley Florist, Chris Spicher; Antelope Valley Indian Museum, California State Department of Parks and Recreation; *Antelope Valley Press*, Karla Archuleta; Aven's Furniture and Robert Turner; Lee Baron; William Bishop; Dr. Jacqueline R. Braitman; John Calandri family; Cyrus Carol; Anna Carreon; Ulysses Chatman Jr.; Clayton Historical Society Museum and Mary Spryer; Katie Corbett; Janette Crawford; Barbara Daggett;

William Deaver; Dayle DeBry; Olivia de Haulleville; Jessica Derrick; Frances DeWolfe; Lynn Crothers DuPratt; David Earle; East Kern Historical Museum Society and Steve Colerick; Bertil Falk; Marge Freeman; Tink Lott Freeman; Ronald Garcia; Hart Printers, Donald Hart Sr. and Donald Hart Jr.; Hunter Dodge Chrysler Jeep; Kern Antelope Historical Society (KAHS); Tim King; Sandra Luckeroth; Henry Marvin; Cora Sweet McCrumb; Elaine McDonald; Dr. H. Gregory McDonald; the Moulton family, Barbara and Cliff; Patricia B. Paige; Charlene Dodenhoff Patterson; Lois Patton; Ronda Perez of the City of Lancaster; Maryanna Pickelok; Jane Seymour Pinheiro; Cesar Portillo; Jim Reddish; Wendy Reed; Michael Riccomini; Peggy Ronning; Larry and Kathy Rottman; Diana Satterfield; Dorene and Glen Settle; Ron Siddle; Sheila Sola; Earl Specht; Frank Sperling; St. Andrew's Abbey; Milt Stark; Barbara Sterk; Charlene Taylor and the Folgate family; Mercedes Metz Taylor; Jay Tremblay; University of Southern California—on behalf of the USC Special Collections; Siggy Wessberg; West Antelope Valley Historical Society (WAVHS); Yuba County Library; Patrice "Candy" Zappa-Porter (*My Brother was a Mother: Take 2*, page 42); and my always patient and loving husband, Ronald Kleit.

Unless otherwise noted, all images appear courtesy of the City of Lancaster Museum of Art and History (LMOAH). All of the author's royalties go to the LMOAH nonprofit Lancaster Museum and Public Art Foundation to support local history exhibitions.

INTRODUCTION

Unlike most of Arcadia's Legendary Locals publications, which are devoted to an individual city, this book focuses on an entire region: the Antelope Valley (except for Boron and Edwards Air Force Base, which are covered in other Arcadia publications). The area's history spans the period of early Native Americans, explorers, the coming of the railroad, pioneers, and the supersonic era in modern times.

The area's many small and large communities together give the Antelope Valley its special character. The sprawling valley measures approximately 2,500 square miles, which is larger than the states of Rhode Island and Delaware. The valley, situated in the westernmost section of the Great Mojave Desert, is bordered by two mountain ranges. Although the region is located about 65 miles northeast of metropolitan Los Angeles, its distance and isolation have resulted in many of its residents—both past and present—not necessarily being connected to only one community. Some residents are instantly synonymous with the Antelope Valley and have been discussed extensively. Most, however, never made headlines or knew fame in their lifetimes. Nevertheless, all of these people, through their struggles, determination, and passion, have left indelible marks on the valley.

In the larger historical context, it has not been that long since the first non-Native person set foot in the region. The earliest explorers into the Antelope Valley, from 1772 to 1806, were Hispanic. Prior to the arrival of these early trailblazers, the region was inhabited by five tribes—the Kawaiisu, the Kitanemuk, the Vanyume-Serrano, the Chemehuevi, and the Tataviam. These Native American groups are often collectively referred to as Piute or Paiute Indians in older books. The earliest written information about Antelope Valley Indians is found in journals from the first recorded entry of a European explorer, Capt. Pedro Fages, in 1772.

The first Europeans to enter the valley, however, were probably three or four unknown Spanish army deserters. Fages, a Spanish infantry officer, was engaged in a long pursuit of these renegades. It is unlikely that a journey of such length by a well-equipped army unit would have been for the sole purpose of capturing deserters. The expedition was probably also charged with searching for a reliable second land route to supply the northern missions. Fages began his trek from the San Diego area and continued through the southern section of the Antelope Valley.

In 1776, the year the Declaration of Independence was signed, Fr. Francisco Garcés (1738–1781) crossed the Antelope Valley. Although he was the first Spaniard to discover the Mojave River, his primary objective was to find an inland land route from Sonora, Mexico, and the Colorado River to Monterey. Garcés may have conducted the first Roman Catholic Mass in the Antelope Valley (near Lake Hughes). During his travels to the north, he encountered evidence of Spanish deserters.

For a few years after initial contact, Spanish expeditions in the Antelope Valley were sporadic. The Spanish made no attempt to establish settlements or map the area. By 1820, the combined effects of European diseases and forced or

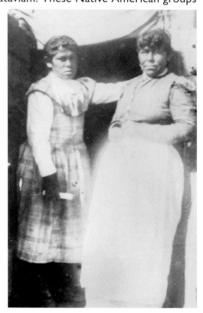

Native American Valley Women Two unidentified Native American valley women, who worked for the Mojave Borax Company, are shown here around 1885.

voluntary removal of local Indians to Mission San Fernando had devastating outcomes. Although there were never any Antelope Valley missions, in 1853, the US government established the Tejon Reserve (also known as the Sebastian Indian Reserve), located in the mountains at the western edge of the Antelope Valley. The reserve was administered by Gen. Edward F. Beale. Only about 50 Antelope Valley Native Americans were sent to the reserve.

Between 1827 and 1845, several prominent figures in California history traveled through the Antelope Valley, including Jedediah Smith (1799–1831), the first American to trek across the valley; Kit Carson (1809–1868); Ewing Young (1799–1841); and "Pathfinder" John C. Frémont (1813–1890). Like the Spaniards before them, these intrepid explorers made no attempts to settle the valley. In 1853, the US War Department railway survey expedition, led by Lt. Robert S. Williamson, surveyed the valley for possible routes for the Southern California line of a proposed transcontinental railroad.

All the explorers' contributions were vital in opening the way for the settlers who would soon follow. During the 1850s, the earliest pioneers settled in the Elizabeth Lake and La Liebre areas; their activities were mostly limited to cattle and sheep grazing, prospecting, and running stage stops. The majority of the valley's colonies were established in the mid-1880s, the era of the famous Southern California "land boom."

Most pioneer valley transplants seemed to enjoy living in the area. In 1897, young Maude Emerson, who settled in the present-day Pearblossom area with her parents, wrote to the *Farm, Field and Fireside* magazine: "I am a little girl ten years old. I live in Almondale. We came here from Chicago a year and a half ago. I like to live in the country as we have lots more fun here than we do in the city. My papa is in Chicago. He is a doctor and he is coming out here soon. I have two sisters. . . . My papa has 20 acres in almonds and olives. . . . We have a lovely big dog named Gyp. He plays hide-and-go-seek with us. I have seen two coyotes. They took some of mama's chickens. We have nice weather here all the year around." But there were hard times as well. From 1895 to 1905, Southern California was hit by devastating drought, and Antelope Valley homesteads were abandoned as many people moved away. It took several years for the population to grow again.

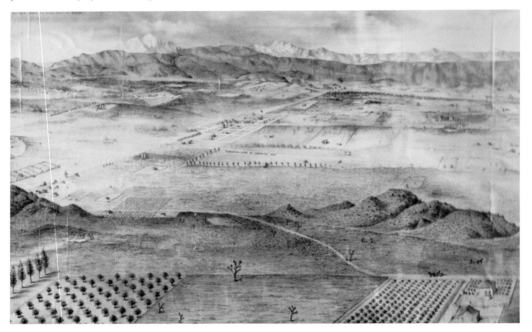

Antelope Valley Lithograph
This lithograph from a Rosamond hilltop looking south shows the entire Antelope Valley in 1887. Copies of this map were most likely used as a real estate promotional item.

CHAPTER ONE

Early Settlers and Community Namesakes

Who were the pivotal community settlers and founders in the valley, and how did the Antelope Valley receive its name?

It is not exactly known when this region was first referred to as the "Antelope Valley," but it most likely dates to the period following Lt. Robert S. Williamson's railroad survey expedition in 1853. The valley is named after the pronghorn antelope, America's swiftest animal. Sightings of them were common by early explorers and pioneers, but for various reasons, the species vanished from the valley by the late 1930s and early 1940s.

Although archaeologists can identify a few Antelope Valley Indian *rancheria* sites, such as Tsivung near Elizabeth Lake, and Kwarung ("frog" in a neighboring Indian dialect) by Lake Hughes, none of their original names or translations lent themselves to modern communities. Nor have any valley towns been named after historic Native Americans.

Spanish words can be seen in some location names, such as Esperanza (hope), Llano del Rio (river plain), Ana Verde (green Ann), which is a corruption of Llano Verde (green plain), the Manzana (apple) Colony, Tierra Bonita (pretty land), and Del Sur (of the south). Other towns were named after prominent features, such as Big Rock Creek, Sand Creek (later known as Rosamond, supposedly named after the daughter of a Southern Pacific Railroad official), Juniper Hills, and Quartz Hill.

Several early communities were named after settlers, but in many cases, only the first names are used, such as Myrtle and Harold. There are instances in which the namesake's last name is preserved. Muroc is derived from the Corum family. Edwards Air Force Base is named in honor of Capt. Glen Edwards, the copilot on the YB-49 Flying Wing that crashed near the Muroc Air Base in 1948. Leona Valley is named after Miguel Leonis. There is the John Brown Colony, and Wilsona is named after Pres. Woodrow Wilson. Lake Hughes gets its name from either sheepherder Patrick Hughes or another pioneer, George Hughes.

Avid promoters, like Nathan Mendelsohn (California City) and Job Harriman (Llano del Rio Cooperative Colony), purposely established a community for specific benefits.

Ann Elizabeth Covington Dearborn

Ann Dearborn (c. 1846–1910) was one of the first white non-Hispanic females to settle in the valley. Born in Indiana, she and her family crossed the plains in an ox-drawn prairie schooner. During the trip, she met and married William Covington. They settled in Salt Lake City, but when William wanted to take another wife, Ann ran away with her six children to Nevada, where she opened a rooming house. She was soon traveling again, this time to Los Angeles via the Antelope Valley. While living in Los Angeles, she ran a rooming house and rented out freight teams. After divorcing Covington, she married Elias Marquess Dearborn, a forty-niner who had also mined around Havilah. The newly married couple settled in the Antelope Valley in 1869, and Elias began raising cattle in an area called Indian Springs, east of Rosamond. Ann said that although Indians were frequent visitors, they never bothered her family. They then moved to an area west of Mojave, where Elias built a stage station called Cactus Castle, and later to Twin Lakes and Rincon. Ann reported that, once, when Elias was gone, the notorious Tiburcío Vásquez and his gang of 10 bandits visited their house. Not looking to cause any problems, Vásquez told Ann that he was only searching for a place to stay overnight. Ann refused, as the cabin had only two rooms. The men did stay—but only after they turned over their guns to her. Upon leaving, Vásquez offered to pay Ann for her hospitality, but she refused. However, he did give her son, John, a $5 gold coin without her knowledge. Like most pioneer women, Ann made soap in quantity to last about a year, fashioned her own candles, and knitted socks and mittens. She milked cows, made cheese, and sold butter. Her garden potatoes were sold in Bakersfield, as Lancaster, Mojave, and Palmdale did not yet exist. One of her daughters, Mary, married John Searles, who later discovered borax at Searles Lake. Searles's friend and partner, Eben Skillings, married another daughter, Nancy. After Elias Dearborn died in 1907, Ann moved to Mojave, where she died. Ann is the great-great-great grandmother of Dorene Settle, the donor of this photograph. (Courtesy of Dorene and Glen Settle.)

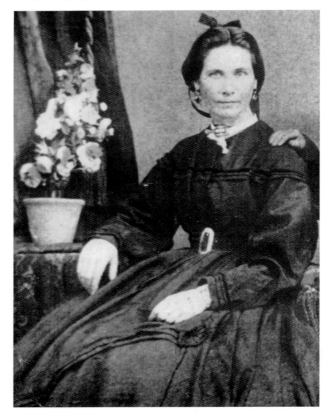

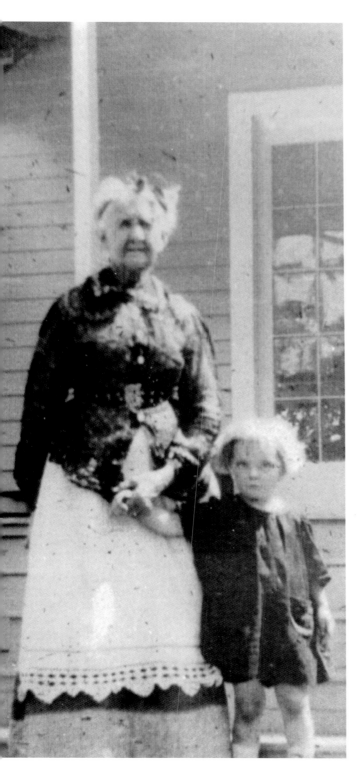

Almeda Mudget Frakes
In 1849, when Almeda Mudget Frakes (1839–1934) was 10 years old, she and her family journeyed west from Texas with a wagon train. The only education she ever received was from a fellow female traveler during this journey. She later decided that her future children would fare better and acquire a more suitable education. During this dangerous crossing, her mother died, and, later, her father was killed by a grizzly bear. She and her three siblings were taken into the home of a family who had traveled west with them. At 16, she married Samuel H.T. Frakes (1830–?), a cattleman who hauled lumber to build neighboring Fort Tejon in 1854. After selling their Central California home, the newlyweds set out for Arizona via Elizabeth Lake, but when they heard about the dangerous raids of Chief Geronimo, they decided to settle near Del Sur. When drought conditions developed, they moved and homesteaded at Elizabeth Lake with their nephew Frank Frakes. When the Frakes had children, Almeda remembered her childhood vow regarding the importance of education. In 1869, with the help of neighbors, Almeda and Samuel donated land and established the area's first school, an adobe structure. At the time, this was the only school between Newhall and Bakersfield. Different schools would occupy three sites on the Frakes ranch over the years, and none were deeded to the Elizabeth Lake School District until 1958. At the Lancaster Western Hotel Museum, the Mudget pump organ, which came to California in 1849 by a covered wagon, is on display. It has been in the Antelope Valley since about 1856. This photograph shows Almeda and her niece, Donna May Thomas-Kahler, standing in front of a family house in 1923. (Courtesy of Donna and William Kahler.)

11

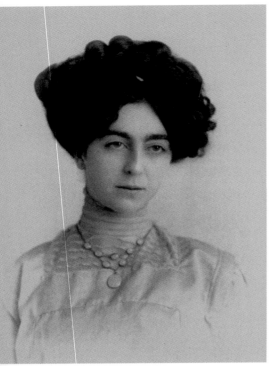

Nellie Almeda Frakes Thompson

Valley historians are familiar with the Frakeses' early lives, as they told their history to their niece, Nellie Thompson (1888–?). Born on the original Frakes ranch, she attended the old lower Elizabeth Lake School. She signed the deed in 1958 for the Elizabeth Lake School District. Thompson was the honored guest at the 1960 Old Timers Barbecue, being named the "oldest resident old timer." (Courtesy of Donna and William Kahler.)

Corum Family

In 1910, Clifford Corum (1881–?) and his wife, Effie (1888–1983), settled near what was then Rodriguez Dry Lake. Soon, the community needed a post office. The first name submitted was Corum, which was refused, as there already existed a similarly named town. In 1911, Effie reversed the spelling, and Muroc was founded. Today, the community is known as Edwards Air Force Base. In this photograph, Effie (center), Clifford (far right), and other family members stand near a well.

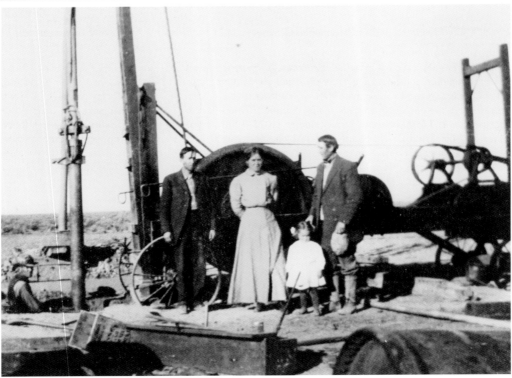

Margarita Ruiz Hefner

Margarita Hefner (1849–1935), her widowed mother, Doña Nieves Ruiz, and her six siblings fled a smallpox epidemic in Los Angeles in 1867 and trekked to Elizabeth Lake, which at the time had only a few settlers. Nieves set up makeshift quarters at the lake and prepared meals for passing teamsters and other travelers on the Los Angeles–Elizabeth Lake–Fort Tejon–Sebastian Reserve road. When Margarita was 17, she married James Hefner (1825–1908), a passing teamster who had been a forty-niner and blacksmith. The Hefners took over Margarita's mother's stage stop, which then became known as Hefner's Station. Margarita also served as Elizabeth Lake's postmistress. In 1915, the *Antelope Valley Ledger-Gazette* offered prizes for stories regarding the valley's earliest pioneers who still lived here. The first prize, a lifetime subscription to the newspaper, was won by Margarita.

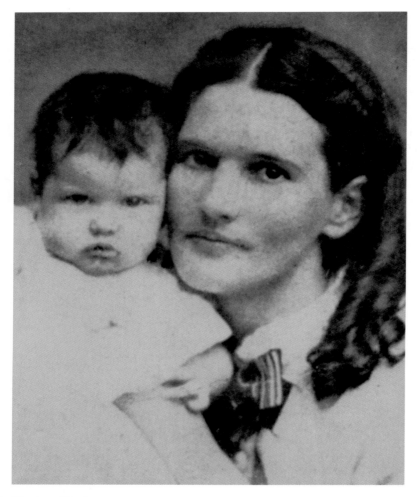

Elizabeth Clayton Clark

There are two folklore versions regarding the naming of Elizabeth Lake. The most often repeated but undocumented story is that it was named after Elizabeth Wingfield, who supposedly fell into the lake while traveling north in 1849. However, the region was probably not settled until around 1854, when Fort Tejon was being built and traffic to the northern gold fields through San Francisquito Canyon was increasing. The lake may have been named after Elizabeth Clayton Clark (1844–1911). Around 1859, Elizabeth's family started a stagecoach, trading post, and dining establishment at their Tavern House and Ranch by the lake, serving passengers on the road to and from Los Angeles. The stagecoach drivers came to like young Elizabeth. When they stopped for meals, she would always have the correct number of plates ready for the passengers, who wondered how she knew exactly how many people were going to eat. In actuality, the stage drivers would always honk exactly the number of people who were ready for their meals. Elizabeth's parents sold their stage stop in the early 1860s. Three of Elizabeth's siblings were buried near the lake. When Elizabeth married Charles Haskell Clark Jr. in 1864, Phoebe Apperson Hearst, William Randolph Hearst's mother, was her matron of honor. Elizabeth spoke four languages (English, French, Spanish, and Italian) as well as three Native American dialects. She was also trained in opera singing. The city of Clayton in Contra Costa County, California, is named after the Clayton family. This photograph of Elizabeth and her daughter, Grace Margaret, dates to 1874. (Courtesy of the Clayton Historical Society Museum.)

Nathan "Nate" Mendelsohn

Visionary Nate Mendelsohn (1915–1984) was a born salesman. He envisioned a master-planned metropolitan oasis—California City—in the Mojave Desert, which he thought would rival Los Angeles. Born in Czechoslovakia, Mendelsohn was a Columbia University sociology instructor and a nursing teacher who turned to real estate in the 1950s. He purchased 82,000 acres of land north of Edwards Air Force Base and started working with planners to lay out his community. The lots were very inexpensive, but the various industries, shopping centers, colleges, and financial institutions never developed. Although California City was incorporated in 1965, after years of planning, it never developed as Mendelsohn had imagined. He sold his property and moved on to other projects. Today, around 14,000 residents call California City home. (Courtesy of the East Kern Historical Museum Society.)

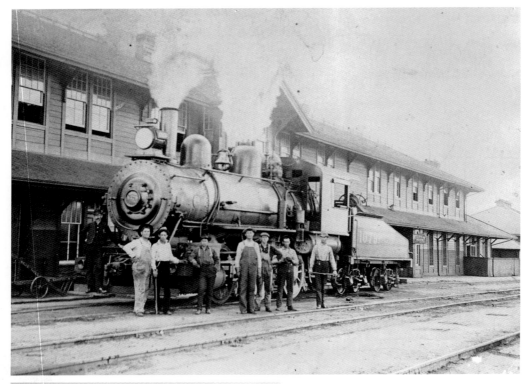

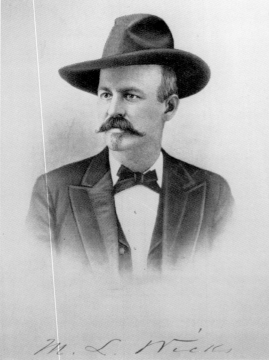

Mojave

Some communities, like Mojave, did not have an individual founder. The word *Mojave* is Spanish for *Hamakhava* or *Hamakhaaav*, the name of the Native American nation on the Colorado River. Mojave was "born" on August 8, 1876, when thousands of workers laying tracks on the Southern Pacific Railroad route from Bakersfield toward Los Angeles reached the community's present-day site. This photograph shows Mojave railroad workers during the 1890s.

Moses Wicks

In 1876, a Southern Pacific Railroad (SPRR) map identified a Lancaster siding track, but not a town. Interestingly, in 1883, a clerk, J.W. Lancaster, was working there. Moses Wicks, a prominent Southern California real estate developer, purchased 60 sections of land from the SPRR and had Lancaster surveyed and recorded in February 1884. It has been erroneously reported that Wicks named the town after his hometown of Lancaster, Pennsylvania, but he was born in Aberdeen, Mississippi.

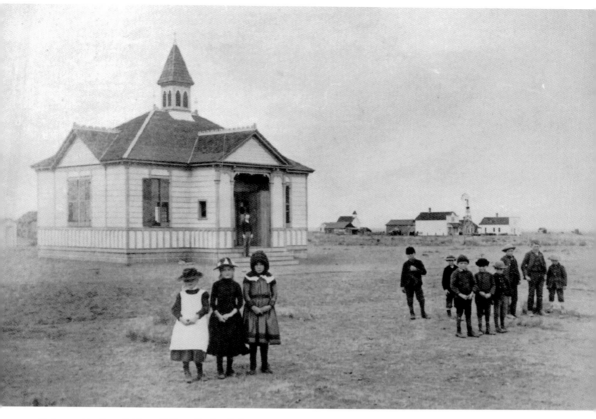

Palmenthal and New/West Palmdale

Two early small communities, Harold and Palmenthal, established in the late 1880s, are considered to be the foundations of what would become Palmdale. In 1886, a group of 60 to 70 German-Swiss Lutheran families migrated from Nebraska and Illinois to California. Land promoters had told them that palm trees grew near the Pacific Ocean. When the pioneers saw the valley's Joshua trees, which they mistook for palm trees, they decided to settle there. They called their new town Palmenthal—German for "valley of palms." The little hamlet, shown here, was called Palmdale by English speakers. In early 1893, as the old German settlement of Palmenthal–Old Palmdale was losing its importance, about two miles west, a new townsite, Palmdale Station (also called New or West Palmdale), developed when the Southern Pacific Railroad installed helper engine facilities.

George L. Arnold
George Arnold (1852–1914) was the manager of New Palmdale. He had been involved with the Big Rock Creek area in 1890 and owned the Arnold Development Company, which claimed to have brought water to the area. Arnold was also a former Los Angeles bank cashier; the treasurer of the California Baseball League (1893); and a member of the state's board of equalization from the Fourth District (1895–1898).

Job Harriman
Located in southeastern Antelope Valley, the non-religious, self-sustaining, and industrious Llano del Rio Cooperative Colony was founded on May 1, 1914, by Job Harriman (1861–1925), an ordained minister who became a socialist lawyer. He ran for governor of California (1898), vice president of the United States (1900), and twice for mayor of Los Angeles (1910s). He lost all the elections. Harriman is pictured in the front passenger's seat at Llano in 1914.

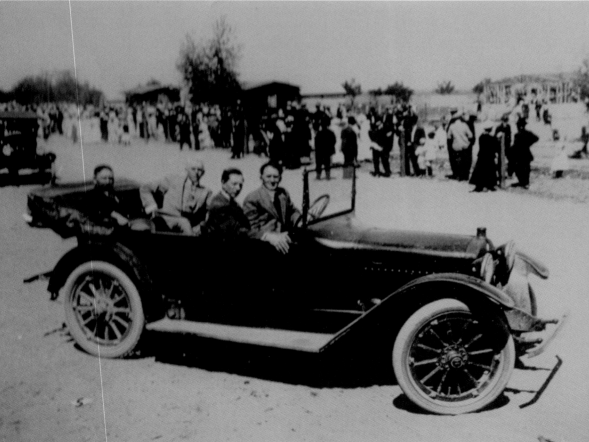

CHAPTER TWO

Farmers, Ranchers, and Cowboys

Early valley residents focused on survival. The area would become deeply rooted in agriculture, but first, the pioneers had to slash down groves of Joshua trees and remove other desert vegetation. During the mid-1880s, which was a period of heavy rainfall, farmers could rely on dry farming. When the drought started, however, many residents moved away. After 1905, the valley's climate conditions began to improve, and the resettlement of some abandoned areas began to take place.

The first town to receive electricity was Lancaster, in 1914, followed a few years later by Palmdale. Although alfalfa played only a small part in the boom of the 1880s and 1890s, with the development of well irrigation on the basis of gasoline and, later, electrical pumps, a tremendous expansion of the alfalfa industry took place in the valley from around 1920 to 1930. Farmers John Almandoz and Yoshio Ekimoto helped make alfalfa king in the valley. John Calandri ventured out and sought new crops to grow, such as onions and carrots, while the Fuller family developed the Antelope melon. Some farmers succeeded with their choices, while others failed.

In addition to agricultural pursuits, the grazing of cattle and other range stock created economic opportunities for many homesteads, especially between 1886 and 1910. Cowboys Henry Specht, Ted Atmore, and Harry Butterworth epitomized the old American West. They rode captured wild horses and drove their cattle all over the valley in search of fodder for their herds.

From the 1950s through the early 1970s, most Californians' Thanksgiving dinners came from local turkey ranchers like Robert Jones, a former boxer, who at one time had more than 70,000 turkeys on his property.

Valley horse owners love their horses, perhaps none as much as Edwin Skinner, a great horseman who rode into his eighties on the riding trails he helped to save.

John Almandoz

John Almandoz (1910–1987) was six years old when his father, Juan, died from complications of working in a mercury mine that has since been labeled a super toxic waste area. His mother, Romualda, emigrated from the Basque region of Spain to the United States, where she later remarried. In 1926, John's family joined relatives already residing in the Antelope Valley. About three years later, John and his brother, Joe, purchased 200 acres at the corner of Ninetieth Street West and Avenue H. During the early 1930s, the entire family worked at the neighboring alfalfa farm, Mission Bell Ranch, owned by John Bell. Times were tough, and they worked around the clock. John became Bell's chauffeur, attracting lots of attention whenever he drove Bell's luxurious Duesenberg automobile. He would let children ride on the "Duesey" car's running boards for fun and even take them to the Lancaster Theater in the car. John was very proud to be a part of the Antelope Valley's pioneer westside Spanish-Basque community. As there were no government assistance programs at this time, the residents worked together to help one another. Five Aizpeurrutia sisters, Romualda among them, ended up in Lancaster, having come from Pamplona, Spain. (Courtesy of the Almandoz family.)

John Calandri

Born in San Fernando, John Calandri (1926–2003) was an Antelope Valley resident for 58 years. During this period, he gained international fame for his onions; his son, "Little John," has stated that Calandri Farms put Lancaster on the "produce map." In 1945, Calandri moved to the valley and began farming. Unlike many other Italians from the San Fernando area who decided to move to Bakersfield, he picked the valley based on its affordability. He quickly became a pioneer of the onion industry and, at one point, dedicated 1,200 acres in the Antelope Valley to the crop. Along with growing onions, Calandri also was a pioneer in the watermelon, cantaloupe, and honeydew industries, and he was one of the area's first sugar beet, lettuce, carrot, and yam farmers. As a leader in the business, he developed the valley's largest cold-storage facility, approximately 90,000 square feet, to store his produce. In 1953, he entered the onion business and soon became known as the Antelope Valley's "Onion King." Today, John Calandri Farms, Inc., continues to sell onions directly to major stores. It was one of the first onion growers in California to do so, and it employs hundreds of people annually. Calandri onions can be found overseas, with exports reaching consumers in Japan, Australia, New Zealand, the Middle East, and Europe. The farm receives visitors from all over the world throughout the year. Always supportive of the community, John Calandri's charitable giving included the Palmdale Fall Festival's Farmers Market; the Rosamond Library; the Cystic Fibrosis Foundation; the Antelope Valley Fair Kiwanis Livestock Auction; the Desert Haven Auction; the National Multiple Sclerosis Society; the Baker-to-Las Vegas law enforcement run; the Open Jackpot Rodeo; the Antelope Valley Indian Museum; and Rosamond Elementary School. For fun, Calandri enjoyed baseball. He coached in the Colt league for about four years and supported valley baseball teams. Calandri Farms is now operated by the second and third generations, John Jr. and Brandon, who continue John Calandri's work in leading the valley's onion industry and providing support to local organizations and merchants. Kathy Calandri, John's daughter, is also keeping with the family and Italian tradition and is currently running a 13-acre vineyard located in Quartz Hill. (Courtesy of the Calandri family.)

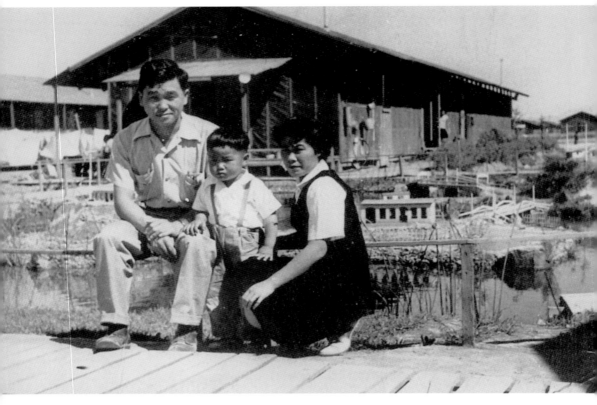

Yoshio Ekimoto

Although some Japanese railroad, domestic, and farm workers had settled in the Antelope Valley in the early 1890s, many began settling after 1910. A valley resident for almost 90 years, Yoshio Ekimoto's (1914–2009) first-generation Issei (Japanese immigrant) parents purchased 40 acres of land in 1912, prior to the passage of the Anti-Alien Land Law of 1913. In 1919, his family moved to their property, which was located around Seventieth to Eightieth Streets West and Avenue D in the Rogers area. As the number of Japanese settlers increased, a Japanese Farmers Association was formed. Later, a community hall was constructed, which also served as a Japanese language school and a church. As a young farmer, Ekimoto went all the way to Japan and married a young Japanese-American, Kiyoko, who was born in Fillmore—only 75 miles away from Rogers! The newlyweds had a peaceful life until the Japanese attack on Pearl Harbor. Although patriotic Japanese settlers were drafted in World War I, it was a different situation during World War II. In his desire to help the United States, Ekimoto wholeheartedly joined the Air Raid Wardens and the Auxiliary Police. But soon, all valley Japanese families received the order to evacuate. Ekimoto asked his good friend, Judge William Keller, to see if he could stay behind and farm for the war effort. Judge Keller wrote a letter to officials but was turned down. In May 1942, Yoshio and his family were among 85 local Japanese immigrants and American citizens forcibly loaded onto buses and sent to an internment camp at Poston, Arizona. Yoshio, Kiyoko, and their son Dennis are pictured at the camp. On his return to California in 1945, Yoshio faced the reality that his more valuable items—firearms, cameras, shortwave radios, flashlights, and their receipts—had somehow disappeared. His farm was so deteriorated that his only alternative was to sell it and pay off the mortgage. Ekimoto estimated his losses in unearned income in the thousands of dollars, but the immeasurable loss he and his family suffered in personal shame and suffering could not be measured in monetary terms. Ekimoto, however, did not leave the valley, working for 23 years at Palmdale's Air Force Plant 42 and for NASA at Edwards. (Courtesy of Dayle DeBry.)

Bernard "Babe" Gaudi

Babe Gaudi (1926–present) is a World War II honoree from the US Marine Corps who fought on Iwo Jima. He was awarded a Presidential Unit Citation for extraordinary heroism in Pacific combat. In 1954, in search of work, he traveled from Pennsylvania to Rosamond and got a job the next day. He first worked on the M&P alfalfa ranch near historic Willow Springs. One day, Dr. Earl Boehm, who lived in Santa Monica, was taking care of a sick patient in Willow Springs and asked family members about people who had good ranching skills who could manage his Bonnie Acres Ranch. Babe was mentioned, and he was given the job in 1957. Boehm's ranch was located at the present-day site of the City of Lancaster National Soccer Field at Avenue L and Thirtieth Street East. It was a good job, as he was living on 160 acres, but Babe had to learn more about the ranching business, such as when to bale, mow, and sell alfalfa. He was up every morning at 3:00. It was a 24-hour, 7-day-a-week job with little time off, but Babe loved being on the tractor. As the farm was near the Palmdale Airport–USAF Plant 42, it was like having an air show on most days. Sometimes, family members would find plane parts on the field.

Babe also did hauling work. He cut in half old Edwards Air Force Base barracks and transported them to Rosamond, where they were turned into apartments. He also tore down the base's old parachute hangars. He enjoyed being a coach for the Eastside Babe Ruth team; the players thought he was a hard disciplinarian. His wife, Magdalen "Maggie" (1928–2002), was not idle during this time. In addition to taking care of seven children and her involvement with the Eastside PTA, she learned how to make chocolate candies, especially chocolate Easter bunnies. She sold them at the ranch and on consignment with the Mills Variety Store in Lancaster. Maggie became well known for her skill in making candy and, later, wedding cakes. Gaudi worked for Boehm for 31 years. He claims to be retired now, but he has been late to his previous three retirement parties—he was still working. (Courtesy of Bernard Gaudi.)

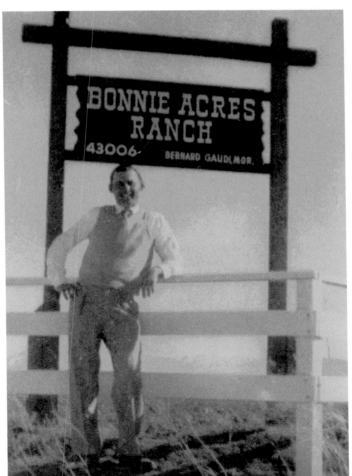

Alfred "Hardpan" Jones

In 1913, Alfred Jones, looking to purchase some land, took a Los Angeles real estate excursion bus to Palmdale. He liked the tract located on Center Street (present-day Palmdale Boulevard), between East Ninth and Tenth Streets. However, he would not purchase it until he conducted a "test;" he got a shovel and dug a hole to see if there was any hardpan. He did not find any, so he bought six acres. From then on, he was called "Hardpan" Jones. Alfred (1859–1931) and his son, Alfred Earl, built the family's home, and Hardpan's wife, Venora (1872–1967), lived there until she died. The Jones family made a living doing different jobs, including selling pears from their orchards; hauling sand with a horse-and-wagon from Little Rock Creek; railroad grading at Vincent; and pulling cars out of creeks. Hardpan was the "Papa" of the Palmdale baseball club (1916), and Venora was one of the town's first librarians. Antelope Valley High School has seen five generations of the Jones family graduate. The school has also been known as Antelope Valley Joint Union High School and Antelope Valley Union High School. Alfred Earl's wife, Ruth Pickett, who came to the valley in 1913, lived to be 107—one of Palmdale's oldest residents. Venora and Hardpan are seen here at their Palmdale home. (Courtesy of the Alfred "Hardpan" Jones family.)

Robert "Bobby" Jones

Bobby Jones, the "Toy Bulldog" of Lancaster (1914–1996), was a longtime east-side rancher and prominent community leader who came to Roosevelt in the Antelope Valley in 1927. While attending Antelope Valley High School, he was always getting into fights, so his coach put boxing gloves on him and made him get out his frustrations in the ring. In 1933, he went to train at the Burbank barn of heavyweight boxing champion James J. Jeffries (1875–1953). From 1934 to 1937, Jones was an amateur boxer, fighting at Jeffries's barn and the Olympic Auditorium in Los Angeles. While he was never a contender for a major boxing title, he was a crowd-pleaser, dubbed the "Toy Bulldog" and Robert "Wham" Jones by ringside fans. He also fought locally at the old Woodman Hall (later Carter's Hall) in matches sponsored by the Lancaster Antelope Athletic Club. During one bout there, Jones faced Jack Hall, "That Palmdale Rose." Jones quit boxing when he married Dorothy Mills in 1937. In 1943, he returned to the valley's east side and became an alfalfa farmer and raised sheep and turkeys for several decades. At one time, Jones was one of the largest independent turkey ranchers in the valley, raising approximately 70,000 turkeys annually. This was during the valley's prime turkey-raising period, when poultry ranchers claimed their turkeys and chickens were dying when jets from Edwards Air Force Base produced sonic booms. Base staff came out to Jones's ranch to film how turkeys reacted during sonic booms. Filming revealed that grown turkeys only gobbled in reaction to the booms, but that the chicks would run into a corner of the brooder house, climb atop one another, and suffocate each other unless rescued by the ranchers. Jones was very active in the community as a member of the Lancaster Elks for 53 years, the Rotary Club, and the Antelope Valley Posse No. 11. He was an Eastside Union School District trustee for 27 years, a director of the Antelope Valley Fair Board from 1957 to 1973, and a founder of the fair's Rural Olympics Committee in 1951. His daughter Barbara Sterk resides near the old family ranch. Jones (right) is shown here at the Swan Memorial Hospital in Palmdale in 1966 with skier John Drgon, whom he rescued with Jack Bones. On the left is nurse Opal Gorman. (Courtesy of the Jones family.)

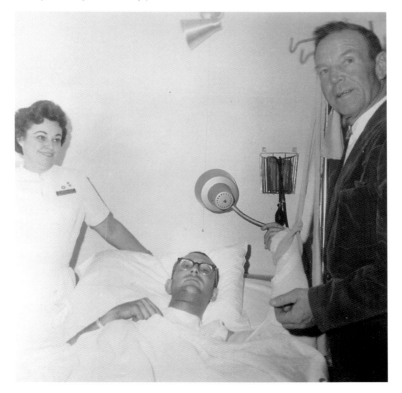

Heinrich "Henry" Specht

When his father contracted tuberculosis, Henry Specht's family moved to Esperanza in 1885. Specht attended the first class at the Del Sur School in 1887; three generations of the Specht family have attended this school. After his father died in 1888, Henry (1878–1948) joined his friend Ted Atmore and became a cowboy, rounding up local cattle herds. When he was 21, he joined the Army and was sent to the Philippines, serving in the cavalry during the Spanish-American War. He may have been the valley's only volunteer to fight in this war. After the war, he went to Dunsmuir, where he worked in the logging business and later became a restaurateur. In the early 1900s, Specht returned to the Antelope Valley and built the Corner Saloon in Lancaster, located at the northwest corner of present-day Lancaster Boulevard and Sierra Highway. He ran the saloon until 1912, when it burned down along with many other businesses. Specht married his girlfriend, Grace Nicholson (they are shown here in 1912), and they homesteaded 320 acres in Happy Valley. He also purchased the Garvin Ranch, which was located next to Richard Shea's Castle. Shea hired Grace to cook for the workers, and Specht became the foreman in charge of building the enormous fence around the castle. Afterward, Specht bought his Del Sur ranch at Avenue I and 120th Street West, where he dry-farmed wheat and barley on 1,400 acres. He was also one of the founders of the Westside Farmers Association and the Westside Store. In 1946, he retired and bought Ted Atmore's Voltaire-Fairmont ranch, where he and Grace lived until his death. Henry loved recalling his father's prediction, before 1888, that Lancaster would some day become a large city. (Courtesy of Earl Specht.)

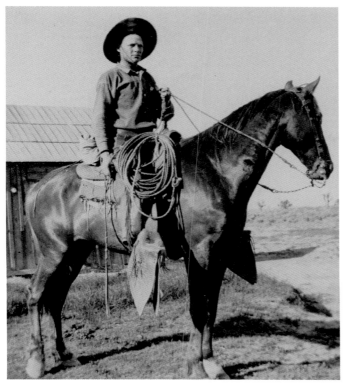

Robert "Ted" Atmore Jr.
Ted Atmore was the colorful leader of a gang of cowboys and eventually owned a herd of 300 cattle. He later ran a general store near Three Points. He called that area Voltaire, for the French author he admired. Atmore (1873–1945) was a consultant for Hollywood cowboy movies. Although he supposedly died from a heart attack, others claimed Atmore was murdered, perhaps the result of his connection to Hollywood honchos.

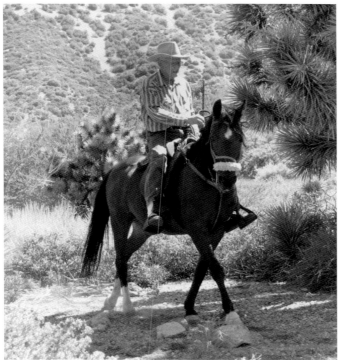

Edwin Skinner
A trail advocate for equestrians and a great horseman, Skinner (1918–2007) was born in Burma. In 1949, he settled in Juniper Hills. The driving force in his life was to ensure that open spaces and trails would always be part of the Antelope Valley. He cofounded the Antelope Valley Trails, Recreation and Environmental Council. Regarding valley trails, he would say, "Use 'em or lose 'em." (Courtesy of Elaine McDonald.)

27

Harry Butterworth

Butterworth figured prominently in the valley's cattle history. He settled in Rosamond and worked with other cattlemen following the cattle. Well-liked, he served as Lancaster's constable from 1898 to 1902 and lived in a small house on Tenth Street (Lancaster Boulevard). One room served as a court and the other as his living quarters. Butterworth (1864–1941) also owned a large barn near the railroad depot. This barn, which was always full of horses and ponies, once caught on fire, and the crying and panicking animals could not be rescued, much to the dismay of the would-be-rescuers and the heartbroken Butterworth. He later served as a clerk for the Los Angeles Criminal Court (1907–1911) and eventually sold his entire cattle business. Butterworth is depicted here around 1900, perhaps getting ready to eat some delicious "cowboy son-of-a gun stew."

Phyllis "Mrs. T" Tremblay
The Antelope Valley has always been a gathering place for horse owners. Phyllis Tremblay (1930–2012) was the last remaining original owner of the Lazy T Ranch. She moved to Palmdale in 1972 with her husband, Joe, to raise their four children. They made many ranch improvements while constantly facing fire threats. She loved the friendly environment of the horse-boarding business and enjoyed hosting ranch and holiday parties—especially for children. Her acting career began with a radio contract at age four, and she later worked in movies with John Wayne, Bing Crosby, and Jerry Lewis. She was in the 1939 classic *Gone with the Wind* and doubled for Natalie Wood and Elizabeth Taylor. Mrs. T's family now runs the ranch. (Courtesy of the Tremblay family.)

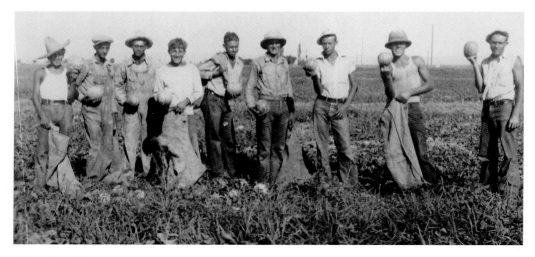

Fuller Family
The Fullers, Glenwood (1878–1951), Celesta (1879–1935), and their two sons, Mort (1912–?) and Austin A. (1904–1996), were farmers in Redman. The family was known for developing the "Antelope Melon" on their 30-acre farm. During the 1930s, the delicious, deep-meated cantaloupe was sold to markets across the Antelope Valley as well as in the best Los Angeles restaurants and hotels.

Samuel Frumkin
A pre-Bolshevik Socialist, Frumkin (1885–1987) fled Russia after the 1905 anti-Czarist revolution and entered the United States with a counterfeit passport. Around 1916, he homesteaded near the Llano Cooperative Colony and became a teamster. He later settled in East Los Angeles, near Mount Sinai Hospital, where he began the hospital's auxiliary support group. Frumkin was also a founder of Workmen's Circle, a Jewish fraternal group. This photograph in Llano, where Frumkin once lived, shows C.K. Eklung (left) and Glen Settle.

CHAPTER THREE

Community Heroes

Many people revere celebrities and athletes as their heroes. However, most real heroes are not people of great celebrity but everyday neighbors. The compelling palette of personalities who have called the Antelope Valley home since the pioneer days has always included heroes—generous-hearted individuals who have shown courage, kindness, and an unselfish character in the service of a community, benefitting many different people.

Their bravery has been demonstrated in times of war, conflict, or police service by risking their lives. Constables chased horse thieves sometimes for hundreds of miles, joined posses, or faced armed desperadoes. An excellent example of personal courage and perseverance was demonstrated by World War I soldier Earl Ramey, who lost a limb in a foreign land but returned to the valley to finish his high school education and later became a college professor. Soldiers experienced the horrors of being a prisoner of war—from Cyrus Demsey during the American Civil War to David Rehmann during the Vietnam War. One did not have to be in the military to be imprisoned and tortured. St. Andrew's Abbey monk Brother Peter Zhou Bang-Jiu was in a Chinese prison for 27 years after the Communists took over that country.

However, it has not only been public servants or enlisted persons who have served as heroes. During the construction of the Owens Valley–Los Angeles Aqueduct, miner Frank Sundeen became a hero when he risked his life to rescue a fellow miner during a tunnel cave-in.

Women have also done their part. Community volunteers have committed countless hours to a special cause. They became involved in war efforts and served as Red Cross volunteers. Barbara Little and Rae Yoshida helped the elderly and victims of domestic violence, promoted children's health care, and worked to establish medical aid programs.

Their accomplishments have stood the test of time. These community heroes who have helped their neighbors in need have truly made the Antelope Valley a better place to live.

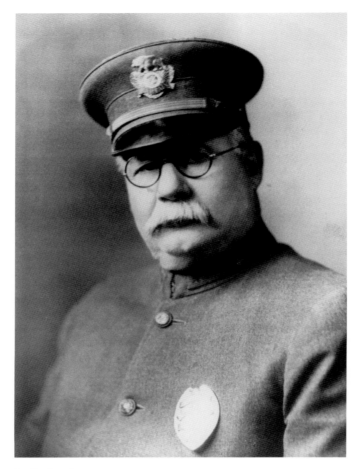

Marcus Fernando Andrade

Andrade (1866–1942) came from one of the oldest families in the Antelope Valley. His Mexican-born father, Pedro (1829–1925), traveled to California from Sonora around 1858. He married Narcissa Valdez, daughter of the influential Californio family, which originally owned the La Brea Rancho in Los Angeles. The Andrades lived in the Leona Valley area. One of their children, Marcus (Marcos), was well liked and became a friend to most of the valley's prominent people. Prior to 1934, law enforcement in the valley consisted of a constable who had under his jurisdiction two townships, Fairmont and Antelope, which were later consolidated. Andrade served as a constable from 1889 to 1891 and, in 1892, was appointed constable of the Fairmont township in place of Henry McCready, who had resigned. He was paid about $30 per month for this position. Although most people believed Andrade would make a good officer, some thought he might be a cattle rustler. During this period, he also managed a large feed store in Lancaster. A neighboring business at this time was the saloon owned by Mace Mayes, who just happened to be the next elected constable and a possible cattle thief. Some residents felt Andrade might have been in partnership with Mayes, but in 1891, Andrade himself had several of his cattle stolen and later charged some of Mayes's friends and relatives with the crime. Andrade was proven to have no connection to Mayes's cattle-rustling gang, and Mayes was sentenced to prison. Andrade later moved away from the Antelope Valley and settled in Anaheim. In 1920, he joined the Anaheim Police Force and served for 23 years as a patrolman, desk sergeant, and captain. A noted horse rider who may have obtained his talents from capturing wild horses in the Antelope Valley during the 1880s, he directed traffic at downtown Anaheim intersections while remaining seated on his horse. (Courtesy of Anaheim Heritage Center at The MUZEO–Anaheim Public Library.)

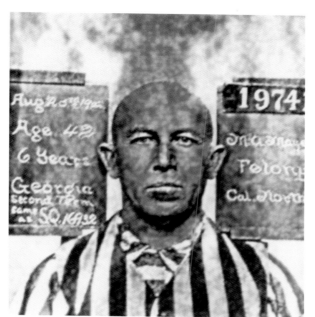

Mace Mayes

Mayes (1866–1942) was not a community hero, but Andrade's adversary. He was associated with the Antelope Valley's cattle- and horse-rustling "Crime of the 19th Century." A constable who operated a Lancaster saloon, Mayes was arrested and, in 1895, convicted of grand larceny with the help of Marcus Andrade's testimony. Mayes was sent to the state prison at San Quentin and was returned there in 1902 for counterfeiting. (Courtesy of Lorraine Kaye.)

Frank Dowler

Dowler (1856–?) came to New Palmdale in the 1890s. At first, he was primarily employed as the town's blacksmith, with a second job as a deputy sheriff. In 1892, he beat Mace Mayes for the constable position. His second job became his main work, and he soon was chasing and arresting vagrants, horse thieves, cattle rustlers, safecrackers, desperadoes, and murderers, as well as breaking up fights in the Palmdale saloon (shown here).

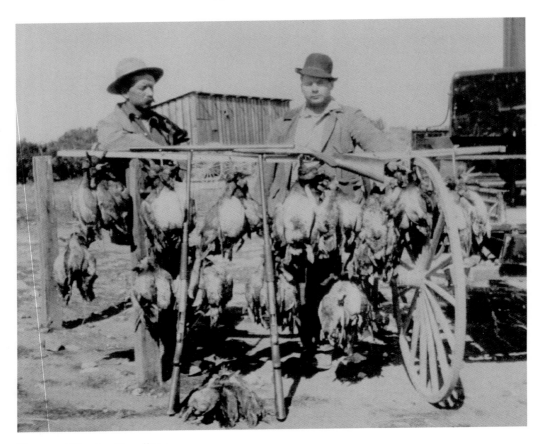

Truman Worthy Hamilton

Truman Hamilton (1883–1940) was the son of gold miner Ezra "Struck-It-Rich" Hamilton. He moved to Willow Springs around 1900 to help his father erect a two-stamp mill and operate the Lida gold mine. He was also the proprietor of the Rosamond Hotel. In 1912, he became the Rosamond postmaster. Later, Hamilton served as a school board trustee clerk for the South Kern County Union School District. In 1922, he changed careers and became a deputy to Mojave constable Frank Drake. He held this position until 1940. Known for possessing a lot of Old West style, he once made Los Angeles headlines, heralded as the unarmed hero for his handling of an armed and desperate escaped convict. Hamilton (right) is shown with an unidentified fellow hunter.

Earl Ramey

Earl Ramey became a valley hero during World War I. Before enlisting at 17, he worked at Lewis's Littlerock General Store and Moore's Palmdale Mercantile. He was sent to Europe and wounded in France at age 18. Upon returning to the United States, Ramey (1896–1989) had a leg amputated. He was given a hero's homecoming in Palmdale. Determined to finish his education, he attended Antelope Valley High School and finished in two years instead of four years. With financial aid from the Veterans Administration, Ramey graduated with a bachelor's degree from Stanford University in 1925, and later earned a master of arts degree. He became a history professor and wrote about the history of Yuba County and Marysville, California. Ramey (second from left) and his wife (second from right) pose with unidentified friends on their wedding day. (Courtesy of Yuba County Library.)

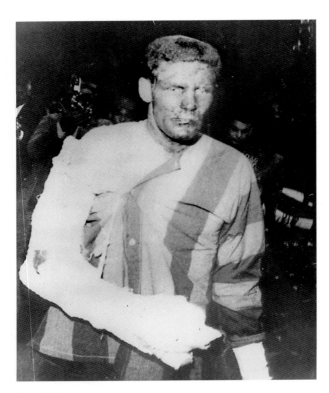

Lt. David Rehmann

David Rehmann (1942–present) graduated from Antelope Valley College in 1962. He was a radar-interceptor operator on the USS *Coral Sea* aircraft carrier when he was shot down over North Vietnam in 1966. He spent more than six years in North Vietnamese prisons, including the infamous "Hanoi Hilton." *Life* magazine featured his symbolic POW photograph. Upon his release in 1973, 4,000 people greeted him at Palmdale Airport. (Courtesy of *Antelope Valley Press*.)

Frank Sundeen

Frank Sundeen helped construct the Los Angeles Aqueduct (1908–1912). Primarily employed as a miner in the aqueduct's tunnels, Sundeen (1884–1968) had to dig out a fellow worker who was buried up to his armpits in sand following a cave-in. At the completion of the aqueduct, Sundeen settled in Rosamond and worked in several local mines. Sundeen (center with hat) is shown with his family around 1920.

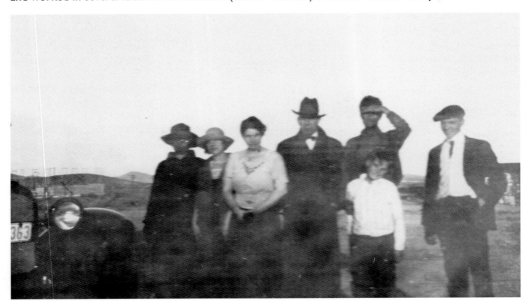

Dr. Cyrus Felix Demsey

Dr. Demsey (1839–1913) is probably the Antelope Valley's only Civil War veteran who was held prisoner in the infamous Andersonville Prison. The son of prominent physicians, he was intrigued with California and traveled there during the 1850s by way of the Panama Canal. He developed an interest in mining, which was cut short with the outbreak of the Civil War. At the beginning of the war, he was a member of the Pacific Coast Navy, but in the fall of 1862, he enlisted in a private company known as the California Hundred, an independent cavalry company. He headed east and then enlisted as a private in Company A, Second Massachusetts Cavalry, defending the Union. He was captured during a battle and experienced confinement in a number of Confederate prisons, including Andersonville, which would come to epitomize the worst of Civil War prisons. At the end of the war, Demsey returned home to Illinois, where he decided to pursue a career in medicine. After receiving his medical degree, he moved to San Francisco and established a practice. In 1890, he relocated to Mojave, attending to the workers and families of the Southern Pacific and Santa Fe Railroads. Living in Mojave rekindled his earlier interest in mining, and he purchased some mining claims. He became the town's postmaster in 1906 and continued in this position until his death in 1913. His wife, Matilda Kern Demsey (1875–1940), who had acted as his assistant, became Mojave's postmistress after his death. Dr. Demsey is buried at the chapel of the Pines Crematory in Los Angeles.

Barbara Little
A former International Tandem Surfing champion, Little (1931–present) moved to Lancaster in 1956. A writer, she has volunteered for various philanthropic groups benefitting veterans, domestic violence victims, and children and providing health care. Little was the first woman on the Lancaster City Council (1982) and the city's first female mayor, serving in 1985–1986.

Una "Pete" Rader Simi
Una Simi was president of both the Lancaster Junior Woman's Club and the Lancaster Woman's Club. A longtime civic leader, during World War II, she was captain and commander of the Antelope Valley Red Cross Auxiliary and monitored aircraft flying over the valley. Simi (1911–2007) was also involved in early fundraising efforts to establish the Antelope Valley Hospital. Simi (left) is being congratulated by Maxine Stoudt in 1951.

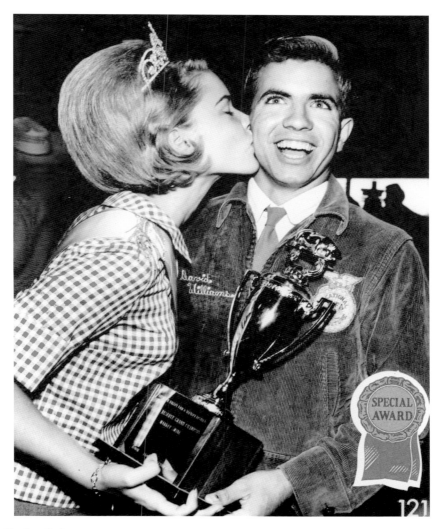

Sheila Taylor Sola
The Taylor family settled at Edwards Air Force Base in 1951. Sheila Taylor Sola (1948–present) entered the Miss Boron pageant in 1965 with the thought that it would be fun, not with a competitive desire to win. She wanted to participate in the town's traditions and celebrations. Her father told her not to cry when she lost. But she did cry—not for losing, but for winning the title of Miss Boron. She cried again a few weeks later when she won the Miss Antelope Valley title. It was a special honor for her to represent Boron and the Antelope Valley at all Antelope Valley Fair events and at other valley-wide community activities, including ribbon-cutting ceremonies, the freeway dedication, local parades, and the presentation of trophies at sporting events. She even greeted Gov. Pat Brown and the next governor, Ronald Reagan. This whirlwind of activities took place at a time when there was no phone service at her home; the nearest phone was seven miles away, and all arrangements were made by mail. Sola has stated that a beauty title sticks to one for the rest of her life; the event still influences what she is today. These activities enabled her to later become involved with numerous charitable events. She is now a licensed general contractor and co-owner of a construction business. Sola is currently helping preserve the valley's history by being a board member of the new Antelope Valley Rural Museum. Sheila is shown here kissing David Williams, who received the fair's Grand Champion Swine trophy. (Photograph by Jim Trehearne; courtesy of Sheila Sola.)

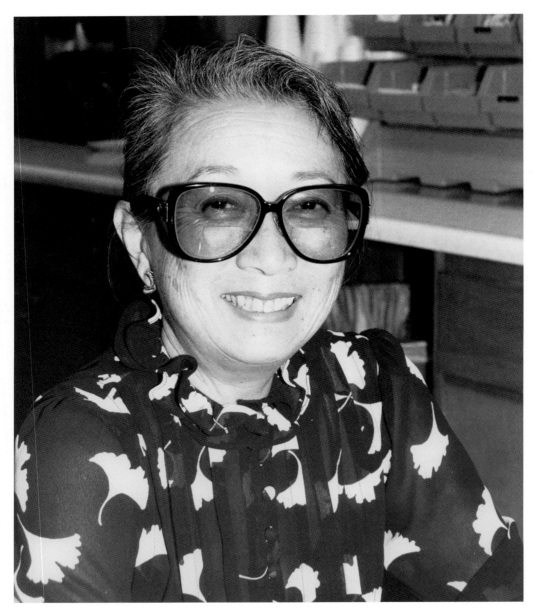

Rae Okamoto Yoshida
Humble Rae Yoshida (1934–1994) was a tireless volunteer who gave much of her spare time to the valley's sick and elderly. In 1942, she and her parents were relocated to the Poston, Arizona, internment camp. After the war, she graduated with a bachelor of science degree in nursing from the University of Michigan–Ann Arbor. In 1966, she became a nursing instructor at Antelope Valley College. She created the college's California State University–Dominguez Hills bachelor of arts degree nursing program. She helped organize a local branch of the Los Angeles Visiting Nurse Association, which today provides thousands of annual visits. The head of the local United Way's planning committee, Yoshida established a branch of the American Cancer Society. She also became Antelope Valley College's vice president of academic affairs. Yoshida is memorialized in a building named for her on campus. (Courtesy of Antelope Valley College.)

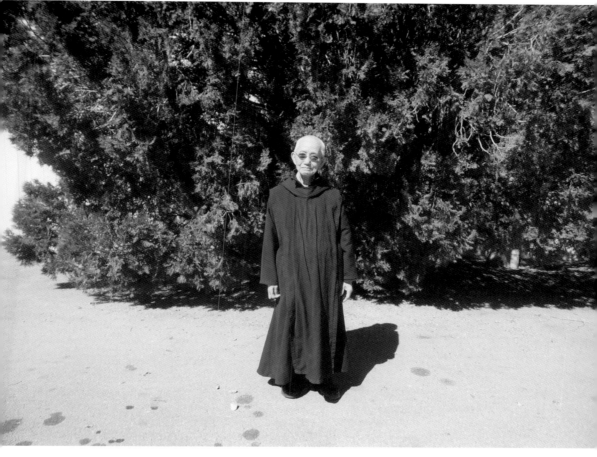

Brother Peter Zhou Bang-Jiu
The Belgian St. Andrew's Abbey was founded in 1929 in China. On Christmas Day 1949, when the Communists took over the region, they outlawed the monastery and placed the monks under house arrest. Br. Peter Zhou Bang-Jiu (1926–present), who had entered the monastery when it was a priory in 1950, was also placed under arrest. He was imprisoned for 27 years and suffered many tortures; his right hand is permanently crippled. In the meantime, his fellow monks had relocated to Valyermo in 1955 and developed the 720-acre St. Andrew's Priory (now the Abbey). They all believed Brother Peter had been murdered. However, in 1984, they discovered that he had miraculously survived, and the Communists released him. Brother Peter was soon able to rejoin his monastic family in Valyermo.

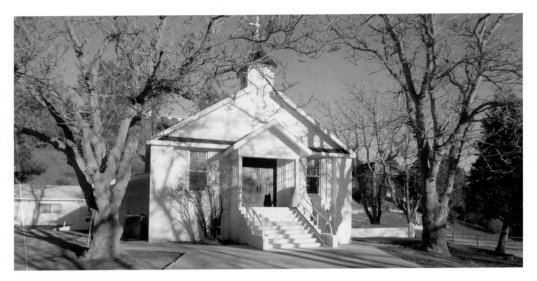

Rev. Henry Clinton Spaulding Keeton

Reverend Keeton (1917–1989) served as pastor of the Acton-Littlerock Presbyterian Greater Parish of South Antelope Valley from 1949 to 1951. He later served at the Church of the Lakes in Lake Hughes (shown here) from 1957 until he retired in 1980. Always committed to the valley, he was the volunteer chaplain at Antelope Valley Hospital from 1973 to 1987.

Capt. Harold Packard Stockbridge

Stockbridge (1913–1986) came to the Antelope Valley in 1940. He enjoyed walking down Lancaster Boulevard and being able to greet the residents by their first names, as well as spotting any strangers. In 1965, the sheriff's department had 1,300 square miles to cover with 76 uniformed officers, all under the capable eye of Stockbridge. He is seen here in the back row, sixth from the left.

CHAPTER FOUR

Miners, Aviators, and Sports Notables

Mining changed the course of the valley's history. For years, the western Mojave Desert has been a favorite place for prospectors and miners to dig, drill, water, and blast the desert floor and the surrounding hills, canyons, and mountains. Mining helped the Antelope Valley survive the drought of the 1890s and the Great Depression. Millions of dollars in ores and minerals have been taken from within or near the valley, including gold, silver, copper, borax, and uranium. Mojave was home to the famous but short-lived Borax 20-mule teams, which would not have been possible without John Searles, Eben Skillings, or John Delameter. Some miners, like Hamp Williams Sr. and Jr., became rich overnight but then quickly lost their money, while others made good investments. Others, however, like Josie Bishop, "Mojave's Madame Curie," never cashed in their claims. Mining activities still continue in the Antelope Valley today.

The valley, also known as America's Aerospace Valley, has long been synonymous with aeronautical achievements that have stirred national pride and imagination. Small airfields were first developed for flight instruction and commercial purposes. Pilot and instructor Fred Alley managed Palmdale's first airfield. During the late 1920s, the military began investigating possible uses for the natural landing fields provided in the dry lake regions. This was the future site of Muroc Air Field and then Edwards Air Force Base, where, in 1947, Chuck Yeager became the first person to break the sound barrier.

In the realm of sports, the valley has produced many athletes who have made names for themselves in baseball, football, motorcycle racing, and boxing. The valley's earliest sports notable, "Antelope Al" Krueger, garnered fame because of a memorable catch and winning touchdown during the 1939 Rose Bowl. The Antelope Valley is also home to Olympic participants, such as Lashinda Demus, a 2012 Olympic silver medal winner.

Josephine "Josie" Stephens Bishop

A former schoolteacher and the mother of seven, Josie Bishop (1864–1951) rolled into the valley in 1925 and settled in Red Rock Canyon, where she staked out 11 mining claims covering 170 acres. One claim contained a rich vein of radium, and she was soon known as the "Radium Queen," "Mojave's Madame Curie," and America's "Number One Woman Desert Rat." She never studied mineralogy or chemistry, but she could pick up a hunk of desert rock and determine almost everything inside of it. However, Josie, who died in a car crash, never cashed in on her claim. (Courtesy of William Bishop.)

Ella B. Kinton
In 1884, Ella Kinton (1866–1944) arrived in Rosamond on a stretcher, near death. She recovered but later faced another medical scare when a wagon with a team of mules dragged her and then ran over her head. She survived and became Rosamond's first female postmaster from 1903 to 1910. Kinton also ran the family's general store, hotel, and livery stable and owned the E.B.K. gold mine.

Donie B. Shumake

In 1934, Donie Shumake began a 20-year association with the Burton Brothers' Tropico Gold Mine as chief clerk and office manager. At this time, she was California's only female member of the Industrial Workers Mining and Milling Association. Shumake (1891–1983) later moved to Lancaster and served on the Antelope Valley Fair Board. Shown here are Shumake (left), Victor Ryckebosch (center), and Jane Pinheiro.

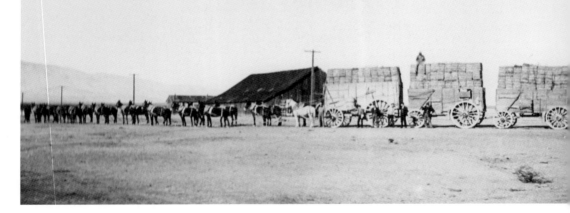

John A. Delameter

In 1882, when William Coleman established the Harmony Borax Company in Death Valley, it was very expensive to transport his borax to the nearest railroad, 165 miles away in Mojave. Seeking to reduce time and transportation costs, he contracted with J.W.S. Perry, a civil engineer, to design sturdy wagons. John Delameter (1854–1936), a Mojave blacksmith and freighter, built 10 wagons at $900 each at Avenue K and Nadeau Street. This c. 1885 photograph shows a 20-mule team wagon built by Delameter. It is loaded with alfalfa in Mojave; the alfalfa was delivered to the borax way stations. Delameter claimed to have named the town of Calico, which became California's leading silver producer.

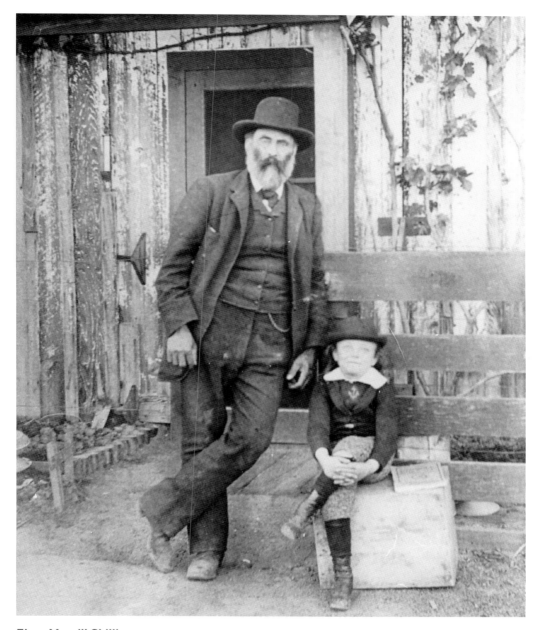

Eben Merrill Skillings

Borax has played an important role in Mojave's history, especially from 1884 to 1889, despite having never been mined there. In 1863, prospector John Searles discovered borax on a dry lakebed (Searles Lake) near modern-day Trona. However, because of financial and transportation problems, mining did not start until 1873. With his brother Dennis and associate Eben Merrill Skillings (1838–?), they formed the San Bernardino Borax Mining Company. When Mojave came into existence, they opened an office there. Operations continued on a large scale, expanding until 1898, when John Searles died. With his death, Francis "Borax" Smith picked up the company for $200,000 and made it a unit of the fast-growing Pacific Coast Borax Company empire. Skillings, the brother-in-law of Searles, is shown with his son in Mojave.

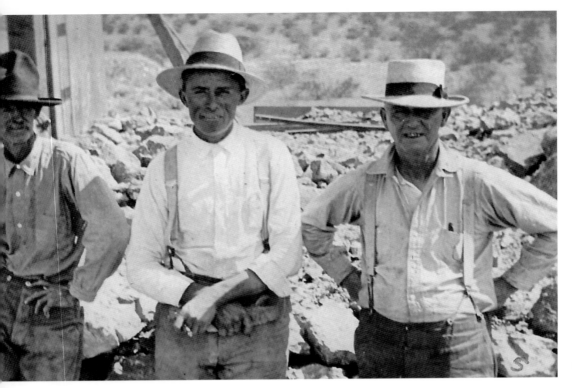

Wade "Hamp" Williams Sr. and Jr.

Hamp Williams Sr. and Jr. each managed to win fame with big strikes 58 years apart. In 1861, Williams Sr. (1817–1899), a placer miner, discovered the famous Joe Walker Mine. He underestimated the mine's value and, a few days later, sold it for only $2,000. The new owner reportedly made $25,000 the first month and went on to become a millionaire. Junior also decided to try prospecting. Luckily, he made a minor strike on practically his first day at the Amelia Mine. In 1919, he and another miner, Jack Nosser, discovered silver at the Kelly Rand Silver Mine. He eventually sold his share in this mine for $50,000. Junior later lived near Rosamond and then Mojave. The miners shown here are Jack Nosser (left), Hamp Williams Jr. (center), and John Kelly.

Charles "Cy" Warren Townsend (OPPOSITE PAGE)

Known by his nickname "Cy," Townsend (1873–1953) was a former professional baseball player with the Syracuse club in the New York State League and Sacramento in the California Coast League. He also played in Bakersfield for the Imperial League. A life member of the National Baseball Association, upon his retirement, Townsend moved to Mojave in 1914. Here he ran the French Café, the Mojave Meat Market, and several service stations. He later invested $500 in the Golden Queen Mine and received a 10-percent interest. In 1921, he was elected Mojave's justice of the peace and served for eight years. (Courtesy of Marge Freeman.)

Fred Arthur Alley

In 1921, Fred Alley opened the Palmdale Mission Garage. He eventually became an automobile dealer in Palmdale and Lancaster. He operated Palmdale's first dirt airstrip, which was located near Sixth Street East and Avenue R. A former Maddux transport pilot, Alley (1894–1965) started the Fred A. Alley Company Air Lines in 1929 and gave flying lessons. Alley (left) is shown at a ground-breaking ceremony with Maree Baker Carter and Joseph Martin.

Florence "Pancho" Barnes

Tough aviatrix Florence Barnes (1901–1975) was one of the valley's most eccentric characters. Around 1933, she moved to the area between Muroc and Rosamond Dry Lakes and became involved with the Army Air Corps professionally and for recreation. She gained notoriety for her Happy Bottom Riding Club and the Rancho Oro Verde Fly-Inn Dude Ranch. (Courtesy of Edwards Air Force Base—HO/AFFTC.)

Irwin "Sparkey" Brandt
Brandt (1901–1998) helped develop the Lancaster Airport (1930), which was at the northwest corner of Avenue I and Tenth Street West. Charles Siebenthal built the first corrugated hangar, and Sparkey, who had a Command Aire aircraft, built the second one. He enjoyed flying in the "old days," when one could take off and land anywhere, without today's many restrictions. (Courtesy of Louis and Annie Brandt.)

Darrell Sherman Curtis
In 1946, flying instructor Darrell Curtis (1916–1990) announced that he could teach students to fly solo in five hours. "If you can drive a car, you can fly an Ercoupe," he claimed. That year, one of the featured attractions at the Antelope Valley Fair was the Ercoupe, advertised as "incapable of spinning." The airplane, shown here, was displayed by Curtis and his partner, Walt Waldrip. Curtis was formerly an alfalfa rancher. (Courtesy of the Grace Fincher Curtis family.)

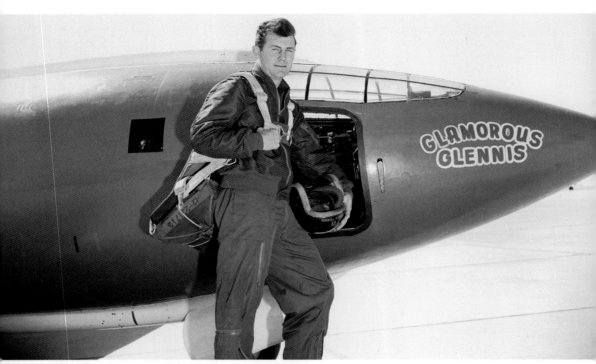

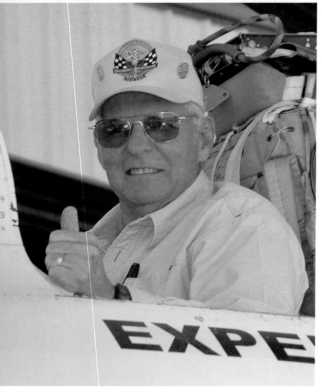

Brig. Gen. Charles "Chuck" Yeager

On October 14, 1947, Antelope Valley residents experienced the world's first jet sonic boom when Chuck Yeager (1923–present), a Willow Springs resident, became the first person to fly faster than the speed of sound. Yeager did so in the Bell X-1 aircraft—the *Glamorous Glennis*—at Muroc Air Base, now Edwards. Over the succeeding years, Yeager flew every type of experimental aircraft at Edwards. (Courtesy Edwards Air Force Base–HO/AFFTC.)

Richard "Dick" Rutan

Rutan (1938–present), who received his pilot's license before his driver's license, successfully circumnavigated the world nonstop on a single tank of gas in the *Voyager* in December 1986. Dick's brother Burt designed the aircraft on a napkin at a Mojave restaurant. With Dick's copilot Jeana Yeager, the *Voyager* took off from Edwards Air Force Base and touched down on the same runway nine days later. (Courtesy of William Deaver.)

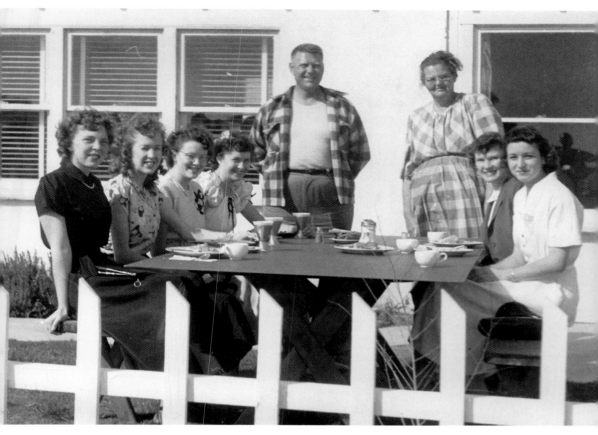

William Lloyd Pike

Quartz Hill Airport was founded by brothers-in-law William Lloyd Pike (1907–1991) and Fillmore Augustus Hoak (1914–2009). Pike was a civilian flight instructor at Polaris Flight Academy at War Eagle Field. After the war, Pike and Hoak opened their airport at Forty-fifth Street West and Avenue L-8/L-10 in 1946. They started the P&H Flying Service and through the years had taught around 500 student pilots. Several airport buildings were erected in exchange for flying time. In 1954, there were more airplanes than houses in Quartz Hill. Pike also started the small Boron Airport in 1947. The Quartz Hill airfield changed hands several times; the last operator was Doc Burch, who ran it from 1968 until it closed in September 1988. In his post-airport days, Pike taught music in the Palmdale School District and later gave private music lessons. Pike is shown with Jane Pinheiro (back row, right) and several ladies at a Quartz Hill event around the late 1950s.

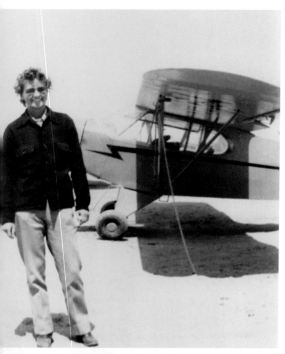

Irma "Babe" Story

As a child, Irma Story (1921–present) performed various tasks at the old Lancaster Airport. She learned to fly in the Civilian Pilot Training program at Antelope Valley College. During World War II, Story became a member of the Women Airforce Service Pilots (WASP). Following the war, she was a flight instructor as well as the co-owner of Antelope Valley Pest Control. In 2010, Story received the Congressional Gold Medal for her World War II WASP service.

Lashinda Demus

Demus (1983–present), the "Pride of Palmdale," made the US Olympic team in 2004 but not in 2008. However, when she won the silver medal in the women's 400-meter hurdles at the London 2012 Olympics, all of America embraced her. Demus says she will be back for the 2016 Olympics and will not stop until she wins the gold medal. (Courtesy of *Antelope Valley Press*.)

James "Jim" Slaton

Jim Slaton (1950–present) is a former major-league pitcher (1971–1986) who began playing at Antelope Valley High School and Antelope Valley College. He played with the Milwaukee Brewers, Detroit Tigers, and California Angels. Slaton earned 151 major league victories during his career. An all-star in 1977, his career was highlighted by winning a game for the Brewers in the 1982 World Series. In 1997, he returned home as the Lancaster JetHawks' pitching coach, serving in that capacity for several years.

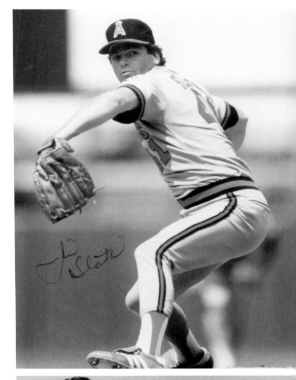

Michael Gaechter

A 1958 graduate of Antelope Valley High School, Michael Gaechter (1940–present) started his professional football career in 1962 with the Dallas Cowboys as a cornerback; however, he earned his reputation as a strong safety. He once intercepted a pass and returned it for a 100-yard touchdown. This was the first time an NFL team produced two plays of 100 yards in the same game. In total, he had 21 career interceptions. Gaechter retired in 1969.

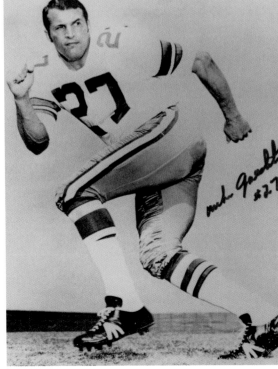

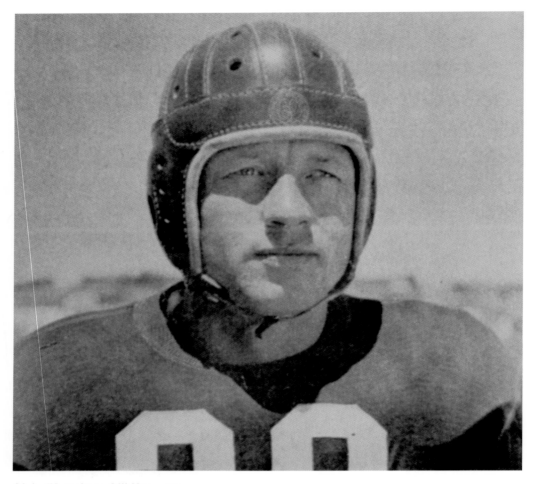

Alvin "Antelope Al" Krueger
Alvin Krueger (1919–1995) is probably the valley's most famous early athlete. At Antelope Valley Joint Union High School, he was a student leader and captain of the 1936 football team. While attending the University of Southern California, he made a memorable catch and winning touchdown during the 1939 Rose Bowl against undefeated Duke University. As a result, Krueger gained sports fame. Sportswriters dubbed him "Glue Fingers" for his amazing ability to hold on to passes. Professionally, he played football with the Washington Redskins and the Los Angeles Dons. He was inducted into the Rose Bowl Hall of Fame in 1995. After World War II, he ran a local tuberculosis sanatorium.

James Arthur "Jim" Lott Jr.

For football pioneer James Lott Jr. (1905–1993), the game was not just a pastime, but his life. After high school, he got the traveling urge and ended up in scenic Green Valley, where his father was an orchardist. But, as it was the Great Depression and Oklahoma was suffering from the Dust Bowl, he returned home to have his family move to California with him and start a new life. Sadly, his mother died the day before the family was to leave. Lott married Rozalia Krzyzewski in 1937 and later owned a bar and pool hall in the Reseda area. Problems arose as many idle young men hanging around his establishment were involved in fistfights. Lott and a local judge felt there had to be a more productive way for the men to spend their time. One activity the boys liked was football, and it promised to be a wonderful way to redirect their energy. Lott established the High Desert League, which ranged from San Diego to San Jose and part of Nevada. It is the oldest continual league in the American Football Association, which is the power that governs semi-pro and minor professional football. It is not connected with the National Football League. The league has been important for men who, although talented, were not able to achieve their NFL dreams. Lott sponsored more than 100 teams and helped at least 8,000 men. Beginning around 1970, he sponsored a team in the High Desert League called the Antelope Valley Sidewinders. Although it no longer exists, he said it was the best team he had in his life. In sponsoring all of these teams, he had to acquire uniforms, a coach, a schedule, and a field to play on.

Lott was known as the "Father of Mexican football" for his efforts in bringing the game to Mexicali and Tijuana. Highly respected, Lott was inducted into the American Football Association's Hall of Fame in 1988. On top of all of that, despite being discouraged as a youth, he went on to become a very accomplished cowboy poet, writing more than 5,000 poems. During World War II, Lott (far right) was the boxing coach onboard the USS *G.G. Morton*. (Courtesy of Tink Lott Freeman.)

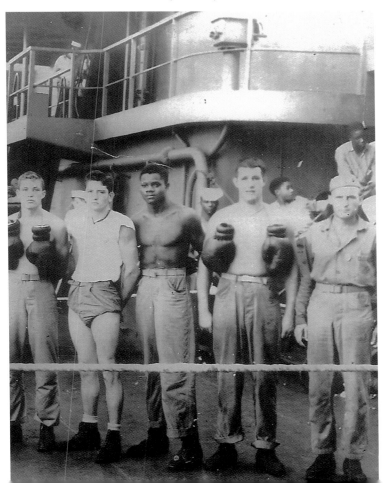

Harold W. Mathewson

Mathewson (1900–2003) spent his teen years at the Llano del Rio Cooperative Colony. His father, Bradford, was an engineer who worked with the community's silos and lumber mill; he designed the silo pictured on page 30. Harold's mother, Annie, was the colony's librarian. The Mathewson family lived in an adobe house they had constructed. While living there, his mother bought him a used motorcycle, which led to his lifelong passion for racing and designing motorcycles. He became a competitive motorcyclist, winning the Pacific Coast Championships in hill climbing in 1932, 1935, 1936, and 1939, and a national championship in 1932. He also designed the 1936 Indian Scout Hillclimber. In 1952, Mathewson built, owned, and managed the X Motel on Sierra Highway near Avenue M. He helped to create the raceway at the Antelope Valley Fairgrounds and at other Southern California locations. During this period, he was still designing new motorcycle products. He established his valley legacy in 1953, when he purchased 607 acres of Willow Springs land and designed the Willow Springs Race Track, shown here. The course included nine turns of varying degrees, a 2,400-foot straightaway, and elevation changes, all of which are basically unchanged today. In 1991, Mathewson was inducted into the Indian Motorcycle Hall of Fame for his many accomplishments in racing and promoting the sport.

CHAPTER FIVE

The Professionals

Various professionals—attorneys, judges, social reformers, educators, engineers, librarians, doctors, and scientists—have given much of their time, energy, and resources to valley residents.

On one day, Justice of the Peace William Keller might be involved in a case dealing with barking dogs. On the next, he might be doing whatever he could to prevent Japanese Americans from being sent to World War II internment camps. A dedicated reformer and a formidable character, Katherine Philips Edson was a prime mover in winning the women's vote in California. She also helped to secure passage of the national suffrage amendment.

Smithsonian Institution ethnographer John Peabody Harrington worked among the valley's Kitanemuk and Serrano tribes around 1916. His field notes have yielded new insights into Antelope Valley Indian ethnohistory. Lois Patton, Mercedes Taylor, and Ulysses Chatman Jr. broke through racial barriers to become leading educators. Mary McPherson, James DuPratt, and Maree Baker Carter were teachers who truly loved their students and wanted to see them succeed.

Doctors Craig Byrne and James Vogel may have initially appeared to be simple country doctors, but they had degrees from the best medical schools. Taking care of their patients was their life. Levi Noble became known as the "Father of Death Valley Geology." In 1903, Lydia Weld became the first woman to receive a degree from the Massachusetts Institute of Technology's engineering school. Dr. William Zontine earned distinction as one of the nation's leading veterinarian radiologists.

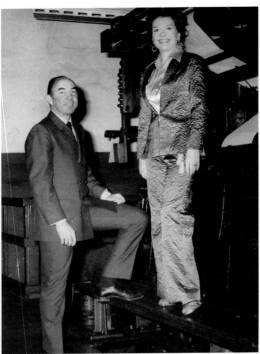

Ross Amspoker

Ross Amspoker's family always told him he would become a lawyer because he was so argumentative. He moved to Palmdale in 1950 and became the town's first full-time lawyer. Amspoker (1921–2006) also served as president of the Palmdale Chamber of Commerce, a trustee of the Palmdale School District, president of the Antelope Valley Bar Association, and the first president of the Antelope Valley College Board of Trustees. He is seen here with Patricia Browning Paige. (Courtesy of Patricia Browning Paige.)

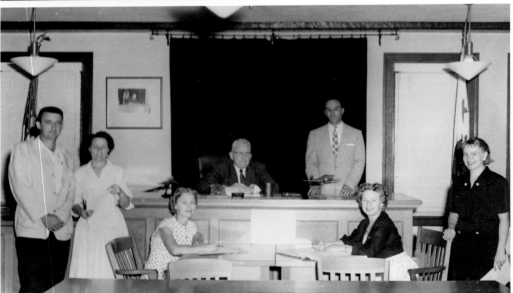

William Keller

Antelope Valley High School graduate William Keller (1908–1968) was the valley's justice of the peace from 1934 to 1956. One of his friends said, "Keller was a very good judge; everyone liked him but the felons." In 1934, he became California's youngest justice of the peace. Keller was actively involved with the Red Cross and the Civil Defense. Well known for speechmaking, he served as master of ceremonies for many special events. Keller, seated in the center, is shown with his court coworkers.

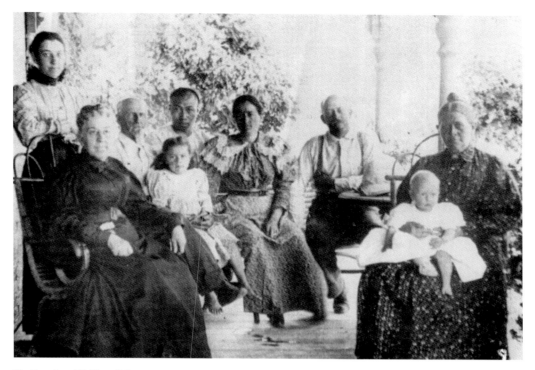

Katherine Philips Edson

Katherine Edson was a grassroots activist in the Antelope Valley. She began as an opera singer and musician, evolving into a social reformer and a suffragette of national stature. In 1889, while attending a Chicago music conservatory, Katherine (1870–1933) met her future husband, Charles Edson. Although Charles's family had founded their own town, Edson (present-day Gazelle) in Northern California, they wanted to establish a new farm. They were not familiar with the valley, but local realtor Dr. Ed Barber helped Charles's parents purchase, sight unseen, their property—the 640-acre Belle Louise ranch—in the Manzana Colony (Fairmont). The Edsons did not plan to stay a long time, but unexpected financial demands, as well as the birth of their daughter, Katharane, in 1892, required them to remain. As the area lacked water, flumes were constructed. Chinese laborers were hired for the almond harvests. Greyhounds were purchased to control the wild animals that were attacking chickens. However, it was fun for young Katharane, as she liked spending time with their cook, Lem, who prepared her favorite meals. In this photograph, Katherine Edson is seated at center, and Lem is seen over her right shoulder. The other family members are unidentified. This is the only documented photograph of a Chinese pioneer in the valley.

In 1891, the Edsons and others helped establish the valley's earliest social and cultural club, a chapter of the national Chautauqua Literary and Scientific Circle, which discussed current and historical events. Katherine also implemented a series of "female round-ups," in which valley women talked about their problems. She wrote a "Woman's Column" in the *Antelope Valley Gazette* (March 1895), campaigning for women's right to vote and discussing social reform issues. Eventually, the Edsons found farm life too difficult, and they moved to Los Angeles in 1899. Young Katharane and her grandparents, however, remained on the ranch another five years. Katherine Edson became a political campaigner and worked hard for public health issues, women's suffrage, minimum-wage legislation for California women, and she helped create the California League of Women Voters, among other platforms. Not everyone approved of her actions. Once, a disgruntled Bishop, California, gentleman wrote to her: "I hope the election has taught you a lesson. A woman in politics is a fright—a horrible sight. Raise some children of your own and stay home . . . good and decent Los Angeles women just despise you!" (Courtesy of Dr. Jacqueline Braitman.)

Amelia Smead and Olin Livesey

During the 1890s, Amelia Smead (1833–1920) worked hard to develop the old Manzana Colony, an agricultural enterprise measuring more than 2,200 acres in the west end of the valley. In this photograph, an unidentified man stands in the colony. She graduated from Mount Holyoke College, and during the 1870s, she was the first woman elected to the Boston School Board of Education. Smead later moved to Los Angeles and became involved with charities, the suffrage movement, women's organizations, and the Children's Hospital.

Olin Livesey (1850–1928) was the leading spirit behind the founding of Theta Nu Epsilon. A graduate of Wesleyan, he wrote for the *New York Tribune* and established different businesses. In 1887, he settled at the Manzana Colony and managed its farming operations. A friend of the Smead and Edson families, he participated in Chautauqua meetings and wrote many articles promoting the valley. He later became a clerk of the Los Angeles Superior Court. (Courtesy of University of Southern California on behalf of the USC Special Collections.)

Lydia Weld

"She can forge a piece of iron like an old veteran and handle a hammer or sledge with the ability of a man." This is an early description of the distinguished Lydia Weld (1878–1962), a woman ahead of her time. She was the first woman, in 1903, to receive a degree from the Massachusetts Institute of Technology's engineering school in naval architecture and marine engineering. After graduation, Weld was employed as a draftsman in the Newport News Dry Dock and Ship Building Company; she worked on the finished plans of all machinery installed in naval ships. She stayed on until health problems during World War I caused her to retire. But she did not remain retired for long. Weld moved to her brother's ranch at Avenue H and Ninetieth Street West in the Esperanza area to manage it. To better prepare herself for the job, Weld took classes at the University of California–Davis to learn the fundamentals of California ranching. From 1915 to 1933, the Weld ranch was a showplace of high-quality alfalfa, pears, sheep, poultry, and hogs, making it an oasis in the high desert. Always analyzing things and using a scientific approach, Weld insisted that ranch work be conducted with horses, refusing to allow a tractor in the alfalfa fields; she said the metal wheels broke down the dykes. Her many community activities included becoming the first female board trustee—and later president—for the Antelope Valley Joint Union High School District in 1923; working to improve the local grammar schools; becoming the director of the Los Angeles County Farm Bureau; writing scientific articles concerning valley birds; and serving as president of the Lancaster Woman's Club (1929–1931). Weld always helped her neighbors and was forever rescuing stray lambs. After her brother George died in 1933, it was time to sell the ranch and move to Carmel. Less than five feet tall, Weld was featured in a recent exhibit, 125 Years of MIT Women. One of the bylines for Weld read, "If a girl comes along who really wants to be an engineer, tell her to go to it." Weld was a woman who did her best wherever she was. She stood up for what she believed. (Courtesy of Anna Dice.)

Mercedes Metz Taylor

The exceptional Mercedes Taylor (1930–present) has achieved several firsts in her career. She was one of the first black students to be admitted to the School of Library Science at Louisiana State University in Baton Rouge after desegregation; the first black librarian to be hired in the Muroc School District and the Antelope Valley Union High School District; and Antelope Valley College's first black librarian. But the road to success was not always easy. Born and reared on a small farm in Jeanerette, Louisiana, she later attended Southern University in Baton Rouge. To help her loving and struggling parents (a farmer and a seamstress) pay her tuition, she worked as a student librarian at the university's library, earning 30¢ an hour. Her husband, William, was working for the Department of Defense when he transferred to Edwards Air Force Base. With a master's degree in library science, Taylor moved to the valley in 1962 and began teaching at Muroc, where her students included the children of test pilots and astronauts. Her next career move was to Antelope Valley High School, where she was a librarian from 1966 to 1969. One of her accomplishments was the implementation of the library's first African American book collection. When a librarian retired from Antelope Valley College, Taylor became the reference librarian. As a young girl, she had a dream—to become a college professor. She fulfilled this dream and retired from the college as a professor of library science. During her 35-year career in teaching and librarianship, she touched the lives of many people, from kindergarten students to adults, and from the bayous of Louisiana and South Central Los Angeles to the Antelope Valley. Taylor is a member of the Delta Sigma Theta Sorority, Inc., and the Delta Kappa Gamma Society. She is a charter member of the Antelope Valley Juliettes, a social service club that promotes better relationships and understanding among women.

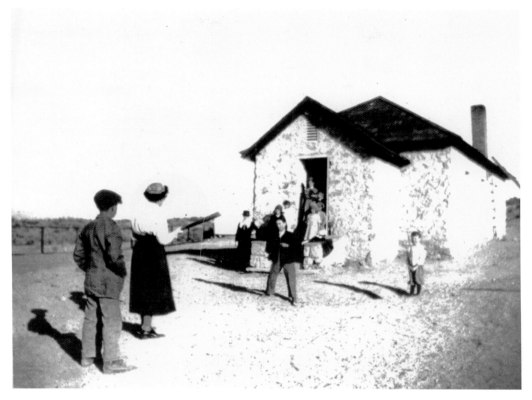

Dr. Emily Ruth Baugh

After graduating from the Los Angeles State Normal School in 1910 with an elementary teaching certificate, Emily Baugh (1889–1973) wanted to continue her education with a doctorate in geography. To finance this dream, however, Baugh needed money. She moved to Willow Springs and secured a teaching position at the community's small elementary school, which was constructed by gold miner "Struck It Rich" Ezra Hamilton in 1904. While teaching in the one-room building, she discovered the unique geological and geographical aspects of the Antelope Valley and began conducting valuable field research. Eventually, she earned the necessary funds to further her education. Her 1926 master's thesis was titled *The Antelope Valley: A Study in Regional Geography.* Baugh began to teach intermittently at the University of California–Berkeley and Los Angeles in 1929. Dr. Baugh became the first woman in the history of the UCLA geography department to achieve full professorship, in 1953, and she was among the first 10 women on the UCLA faculty to be promoted to its highest academic rank. Her favorite course to teach was the geography of California. She also served a term as president of the Association of Pacific Coast Geographers. Dr. Baugh was described as a generous, warm-hearted person who was always willing to help others. She influenced thousands of students, including those from Antelope Valley. In this photograph, Baugh (holding bat) plays softball at the old Willow Springs School.

Lois M. Bennink

Bennink (1897–1982) joined the Antelope Valley Joint Union High School staff in 1926. She was a history and civics teacher and the dean of girls, the senior class, and the honor society. "A lady with a song in her heart," she coached all plays in 1926 and 1927. She became the vice principal in 1927. When Principal Maurice H. Rowell died in 1928, Bennink was appointed the school's first female principal.

Maree Baker Carter

Lancaster resident Maree Baker Carter (c. 1886–1973) was a popular but very strict teacher and principal at Esperanza School. The student body was composed primarily of second-generation immigrants from Greece, Spain, Germany, Russia, Switzerland, and Albania. She worked hard to help them become fluent in English in one year. Maree married John Carter, who was from one of the valley's earliest families. (Courtesy of WAVHS.)

Ulysses Chatman Jr.

For more than 45 years, Ulysses Chatman Jr. (1946–present) has been involved in every aspect of the valley's educational process. He has made his name synonymous with dedication to family and community. Born in Alabama, Chatman's parents were educators who stressed the value of a good education, even though the black students at his school had to rent or buy the white children's used books. They also had to pay 2¢ to 3¢ for a sheet of paper or a pencil. Having survived the rough days of the civil rights movement, Chatman moved to Los Angeles to live with relatives. A high school senior at the age of 15, he later received degrees from Los Angeles City College, California State University–Los Angeles, and Chapman University. He initially wanted to become a doctor, then a lawyer, and finally a teacher. Dr. William Shaw, the first black superintendent of the valley's Wilsona School District, asked him to teach foster children. Chatman accepted the position, but he had difficulty finding a place to live. The only available housing for blacks at this time was in Sun Village, where he rented a room. He later moved near Twelfth Street East and Avenue Q. Chatman was principal at Challenger Memorial Youth Center in Lancaster, and Camps Munz and Mendenhall in Lake Hughes, which are a part of the Los Angeles County Office of Education, Juvenile Court Schools. In addition to being a high school and college educator who has taught thousands of young people, Chatman has also been an assistant basketball coach at Antelope Valley College for almost 20 years. His former students still call to thank him and to tell him that he made them better persons. He is currently an adjunct professor at California State University–Bakersfield and at Brandman University–Antelope Valley. (Courtesy of Ulysses Chatman Jr.)

Sandy Corrales-Eneix
The valley is constantly evolving, and Los Angeles native Sandy Corrales-Eneix (1965–present), represents the newcomers who are making changes in the community. When she moved to Palmdale in 1988, she immediately fell in love with the city's small-town atmosphere. A role model for women, Corrales-Eneix's numerous leadership roles include serving as a member of the Palmdale School District Board of Trustees, the Palmdale Planning Commission, the Palmdale and Antelope Valley Hispanic Chambers of Commerce (as president), the Palmdale Woman's Club, the Democratic Club of the High Desert, and the United Way. She cofounded the League of Women Voters–Antelope Valley and was appointed to the community advisory committee for the Palmdale Sheriff's Station. Most recently, she has been appointed field representative for California assembly member Steve Fox. (Photograph by Ruby Alvarado; courtesy of Sandy Corrales-Eneix.)

James Valentine DuPratt Jr.

James DuPratt's headstone states simply, "Beloved Teacher." He moved to the valley in 1972 to take a teaching position at Quartz Hill High School. It would be the only school where he ever taught. DuPratt (1944–1997) was an English literature and journalism teacher there for 25 years. His wife, Lynn, said, "Unlike many people, he loved high school teenagers. Because they were not a sea of faces, but individuals, he gave his students what they needed most—respect." After a scare with cancer, he wanted to give back to the community, becoming involved with the YMCA, the Kiwanis of Antelope Valley, the Salvation Army Lancaster Corps, the Lancaster Museum/Art Gallery, and Antelope Valley College, where he served three terms on the board of trustees, from 1985 to 1997. A college scholarship is now given in DuPratt's name.

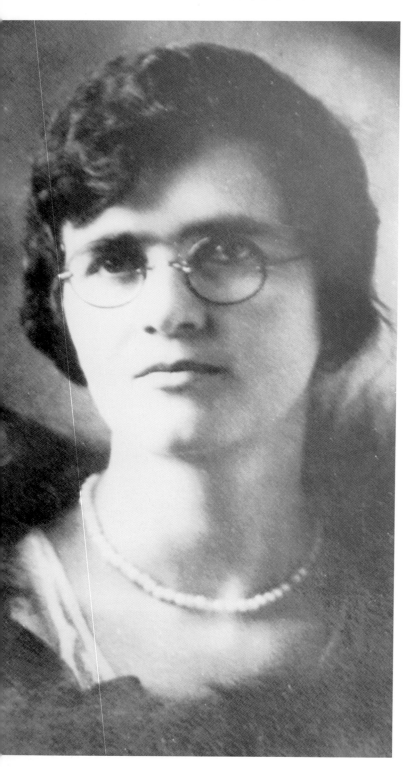

Mary Ince McPherson
McPherson (1891–1989) taught at Wilsona, Del Sur, and Esperanza schools. Her first teaching position was in Oklahoma, with 85 students in a classroom, for $50 a month, plus $7 additional monthly pay for janitorial work. In 1920, her life changed after visiting relatives in Wilsona. The town needed a teacher. She began teaching there, but this time, with only seven students. When the school needed to relocate, McPherson donated three acres of land for the school's new site. In 1961, the Leona Valley Improvement Association honored her for teaching longer than anyone else in the valley, from 1920 to 1956. She then continued as a substitute teacher for 11 more years. In her honor, the Wilsona School's multipurpose room was named the Mary McPherson Hall in 1981. (Courtesy of Milt Stark.)

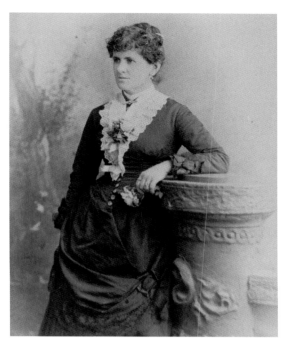

Eulalie Morrissey

In 1880, Mojave consisted of 91 residents, including six children. The only school was a private institution for the railroad employees' children. The Mojave School District, formed in June 1884, opened in a small one-room wooden house. One early teacher was Eulalie Morrissey (1886–?). She was related to the Morrissey family that established the old Mojave Morrissey Hotel. (Courtesy of Lily T. McDonald Stradal.)

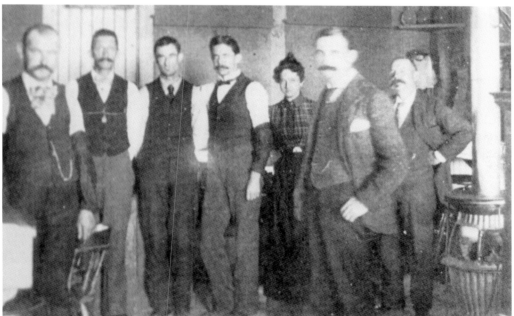

Mamie O'Toole

Almost all early Antelope Valley railroad telegraph operators were male. Mamie O'Toole was an exception. Working at the Mojave railroad depot around 1899, she was called by the townspeople "a crack telegrapher." It is not known what her male workers thought about her work. O'Toole led the way for later female telegraph operators, such as Mary Rayburn in Rosamond (1904), and a Mrs. Mair in Palmdale (1918). O'Toole is shown here with her coworkers at the Mojave railroad depot c. 1900.

Lois Patton

Lois Patton (1924–present) holds the distinction of being the first president of the Antelope Valley Branch of the NAACP. Lois and her husband, Patrick (1915–1985), relocated to the valley in 1954 when he transferred from Burbank to the Palmdale Lockheed plant. The family wanted to live close to work, but Palmdale and other areas of the valley were segregated at the time, and most realtors would not sell to them. The Pattons purchased a one-acre ranch in Sun Village, the only area available to blacks. Although a city girl, Lois decided at one time to raise hogs. The plan did not last long—one of her children fell over a pigpen fence into the slop when trying to feed the animals! In 1957, after receiving a master of arts degree, Patton became a teacher at Keppel Union School in Littlerock, teaching kindergarten through eighth grade students in special programs. She also taught English-as-a-second-language programs for 29 years to children whose parents came to Littlerock to pick pears and then returned to Mexico. When the Pattons needed to purchase a new house, they once again faced housing barriers. The Patton family became one of the first black families to move into Palmdale, at Avenue R-5 and Fifth Street East in 1962. This was the period when the civil rights movement was organizing, and the Pattons received NAACP permission to establish a valley branch; Lois was elected president. Neighbors invited them to visit their church, the Palmdale Methodist Church. Although a little nervous at first, the family joined the wonderful congregation in 1962. (Courtesy of Lois Patton.)

Dr. Norman August Pear

Dr. Pear (1922–1997), a teacher, counselor, and administrator for 36 years, is best known for developing reading programs for the Mojave Unified School District that garnered national and statewide awards. In the 1970s, his work gained national attention when he demonstrated that intelligence quotient (IQ) is dynamic rather than static and can be significantly increased through innovative teaching methods. This is the school district office where Dr. Pear worked. (Courtesy of Maryanna Pickelok.)

Henry Thomas Shirley

The first Palmdale-Palmenthal school opened with former Downey resident Prof. Henry Thomas Shirley (1867–?) as the teacher. The school's 30 pupils ranged from first through eighth graders. Shirley was paid $65 per month, and he served at the school for two terms. He and his wife then went to the Llano Quaker Colony School, where they both taught. Shirley also served as Palmdale's voting clerk for county elections. He is at the far right in the photograph.

Grant Shockley

Shockley (1890–1968) was an alfalfa farmer, a chicken rancher, a Union Supply Company representative, and a door-to-door insurance salesman. What he was most proud of, however, was his service to the Antelope Valley Joint Union High School Board. In 1928, he was elected the Kern County–Rosamond trustee and served on the board for 15 years, 10 as president.

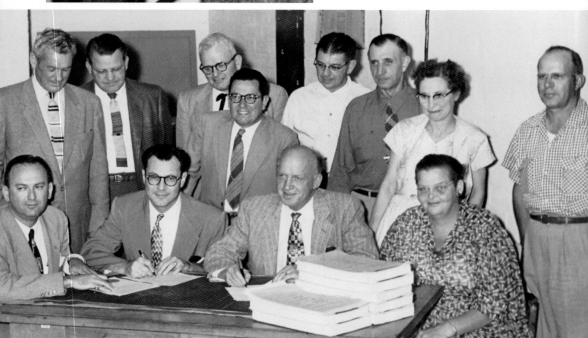

Dr. Craig B. Byrne

Craig Byrne (1904–1984) moved to Lancaster in May 1935. He delivered babies and performed surgeries in his tiny hospital on Lancaster Boulevard. In 1945, Dr. Homer Rowell became an associate of Dr. Byrne. Rowell described him as a good doctor and a wonderful man. Among Bryne's patients were Judy Garland and Pancho Barnes. In this photograph of a hospital planning meeting, Byrne is in the back row, second from left.

Dr. Percy DeWitt Gaskill

A dentist who graduated from the University of California–Berkeley in 1901, Percy Gaskill (1878–1971) was the son of a California forty-niner. In 1896, his father had purchased 640 acres near Rosamond. In January 1916, Gaskill came to the valley to become the manager of his father's DWC ranch, which had more than 500 sheep. Gaskill, which was also sometimes spelled Gaskell, opened his first dental office in downtown Lancaster in 1916 and relocated through the years. He was a lifetime member of the Masonic Lodge and was actively involved with the Lancaster Kiwanis Club. He and his wife, Hazel, showed horses at the fair. He and another Lancaster doctor, Seth Savage, were featured in the popular *Ripley's Believe It Or Not* column on account of their "painful" names. Gaskill was also a close friend of Francis M. "Borax" Smith.

Dr. Philip James Vogel
A 1934 graduate of Loma Linda University, Philip Vogel was responsible for opening the first modern medical clinic in Mojave (shown here), in 1936. His partner was dentist Dr. Thomas Kindel. Dr. Harold H. Snook, who later established his own medical practice in Palmdale, first worked with Vogel. In his later years, Vogel (1906–2001) moved to Pasadena. (Courtesy of Ronald Garcia.)

Dr. William Joseph Zontine
William Zontine (1920–2007) was a Lancaster School Board member, soldier, veterinarian, radiologist, mentor, and skier. From 1946 to 1971, he operated the Zontine Veterinary Hospital in Lancaster. After he sold his practice, he obtained a degree in veterinary radiology and specialized in lameness problems related to large animals. Zontine later became an associate professor of radiology at New York University. (Courtesy of Boulevard Veterinary Hospital.)

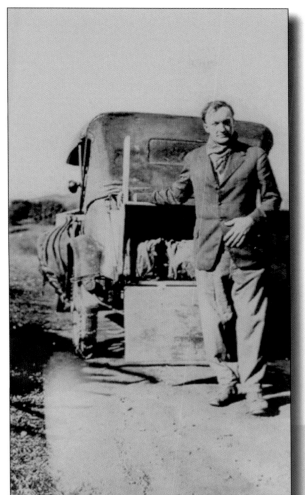

John Peabody Harrington

John Harrington (1884–1961), a Smithsonian Institution linguist and ethnohistorian, was an extraordinary figure in the history of American Indian studies. Although not a valley native or permanent resident, records from the Smithsonian indicate that, beginning around 1916, Harrington worked in the area and stayed at the historic downtown Lancaster Western Hotel while studying regional Native American Kitanemuk and Serrano languages. He collected information on 90 Indian languages. (Courtesy of National Anthropological Archives.)

Chief Juan Lozada

Chief Lozada (1859–1944) was highly respected among the Rancho Tejon Indians. A skilled vaquero, he was associated with the ranch for about 65 years. Although not born or elected a chief, he acted as one for the local Native Americans. Some of his acquaintances said Lozada knew English, but, after being swindled by merchants, he refused to speak it again. (Painting by Charles LaMonk.)

Dr. Hugh "Greg" McDonald

Vertebrate paleontologist Greg McDonald (1951–present) was born in Orange, California. His father was transferred to Utah when Greg was three, and it was there that he developed a budding interest in dinosaurs. In 1959, the McDonald family moved to Palmdale. As his parents, Leslie and Dorothy, were active in the Palmdale Gem and Mineral Club, young Greg went on many field trips with them and became a rock hound. He especially liked places with petrified wood and invertebrate fossils. While attending Palmdale High School, he participated in a special class at the Los Angeles County Museum of Natural History. As a result of this class, he became a volunteer in the museum's department of vertebrate paleontology. Between his junior and senior years in high school, and the summer after graduating, McDonald participated in excavations for the museum's proposed hall of dinosaurs. During these summers, he was part of the team that excavated what at the time was only the fourth known skeleton of *Tyrannosaurus rex*, along with other specimens. As an undergraduate at Idaho State University, one of his museum projects was the preparation of the skeleton of the extinct giant ground sloth *Megalonyx*. Subsequently, his primary research as a paleontologist has focused on ground sloths and their relatives, along with other animals from the Pleistocene era (Ice Age). McDonald received his doctorate degree at the University of Toronto. His research has resulted in more than 90 peer-reviewed scientific papers. He has worked on a National Science Foundation grant to reorganize the Idaho Museum of Natural History's paleontology collections. He was the first curator of vertebrate paleontology at the Cincinnati Museum of Natural History. Afterward, he joined the National Park Service, serving first as the paleontologist at Hagerman Fossil Beds, then as the paleontology program coordinator in the park service's Geologic Resource Division. He is currently the senior curator of natural history in the National Park Service Museum Management Program. McDonald, a 1969 graduate of Palmdale High School, returned to the Antelope Valley as a guest lecturer for the City of Lancaster Museum/Art Gallery's 2000 exhibition Dinosaurs in the Desert. The robotic ground sloth displayed in the show was designed by him for Kokoro Exhibits. However, the curatorial staff was not aware of this—until his mother proudly called to inform them. (Courtesy of Dr. Hugh Greg McDonald.)

Dr. Levi Fatzinger Noble

Leading geologist Levi Noble (1882–1964) and his wife, Dorothy, resided in Valyermo beginning in 1910. "Earthquake Hill" was the perfect location for their home, as Noble investigated the famous San Andreas Fault's structure and geological behavior all his life. Noble, who received all of his degrees from Yale University, started working in 1918 with the US Geological Survey Team regarding mineral sites in Death Valley. He soon became known as the "Father of Death Valley Geology." Although he was visited by the most notable experts of his day, life at the Nobles' home was not always work. During family parties—and sometimes while doing fieldwork—he enjoyed dressing like his favorite fictional detective, Sherlock Holmes. Upon his retirement, Dr. Noble received the US Department of the Interior's gold medal for distinguished service. (Courtesy of Cora Sweet McCrumb.)

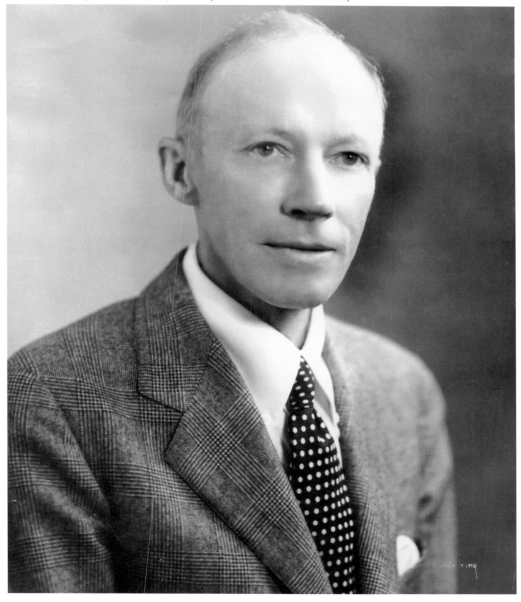

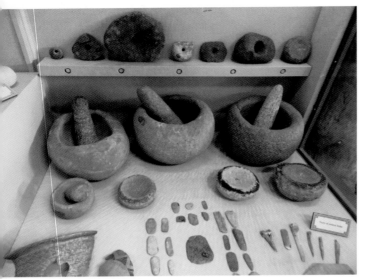

Nestor Young Jr.

The son of a San Diego state assemblyman, Nestor Young Jr. (1875–?) moved to Harold, where his job was sorting and delivering the mail for all of southern Antelope Valley. He later lived at Barrel Springs, where he collected hundreds of Native American artifacts on his extensive property. The pieces were purchased by the University of Southern California and were later transferred to the Antelope Valley Indian Museum.

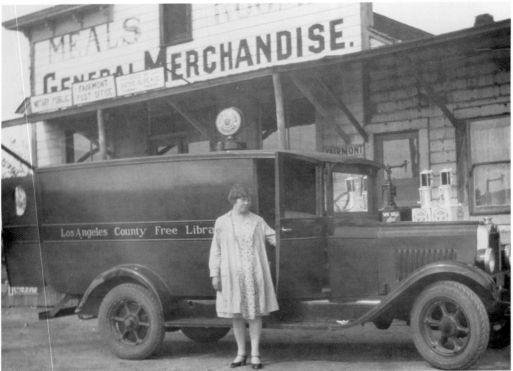

Anna Clark Davis

One of Anna Clark "Clarkie" Davis's dreams was to operate a "library on wheels." She joined the Lancaster Library in 1928. When the library initiated the first bookmobile in California in 1949, Davis (1890–?) became its operator, traveling throughout the valley. In 1957, Davis became the supervisor of the Lancaster Library. After her retirement in 1960, Davis volunteered at Antelope Valley Hospital, wheeling a book cart for patients.

CHAPTER SIX

Artists

Ever since movies began being filmed in the Antelope Valley around 1914, the area has served as Hollywood's back lot. Its proximity to the industry's hub persuaded many actors to move to the valley. Judy Garland's parents moved to Lancaster specifically for that reason, while young John Wayne's family relocated to the valley for health and affordability reasons. George Voskovec moved to Pearblossom in his later years because he wanted to live like an American cowboy.

The valley's cultural life has been enriched by music. Considerable pride was taken in pioneer musical presentations. Local and out-of-town bands, like Ethel Webb's, were constantly in demand to play for parades, dances, parties, and other events. In addition to Judy Garland, the valley's musical heritage includes modern dancer Bella Lewitzky, Donald Van Vliet ("Captain Beefheart"), and the legendary Frank Zappa.

Although most valley residents are familiar with the *Star Wars* movies, few of them have heard of Leigh Brackett Hamilton, who died at her valley home while she was finishing the first draft of the screenplay for *The Empire Strikes Back* for George Lucas. She was called the "Queen of the Space Opera." Another writer, Carlyle Ellis, became known as the world's foremost producer of nontheatrical health and social service films.

Valley residents certainly owe a debt of gratitude to photographer Frank Stubbings. For almost 60 years, he took thousands of photographs for thousands of customers. He also restored many pioneer pictures. His photographs have documented the Antelope Valley's visual history.

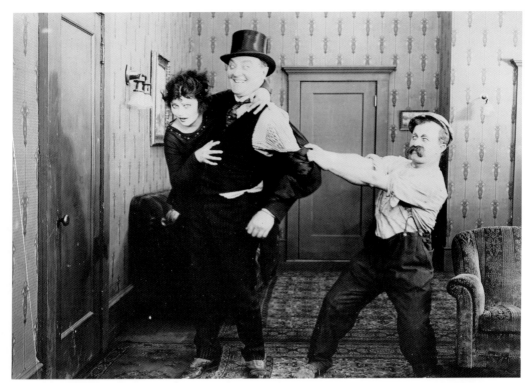

Chester Conklin

An early circus clown and vaudeville actor, Chester Conklin (far right) gained fame as an actor in the Keystone Cops movies. He first visited the valley when an untitled Keystone Cops movie was filmed at Red Rock Canyon around 1912–1914. He appeared in more than 280 films. In 1949, Conklin (1886–1971) had a turkey ranch off the old Mojave-Randsburg Road. His property was later purchased by Nathaniel Mendelsohn, the developer of California City.

Frances Roberts Hatton

Frances Hatton (1887–1971) made her first silent movie in 1921. She was married to Raymond Hatton, also an actor. The couple moved to Palmdale in 1963. While living there, the Hattons enjoyed attending community events and discussing their movie careers. Soon after celebrating their 63rd wedding anniversary, Frances died at Palmdale Hospital. Only five days after her death, Raymond passed away in their home.

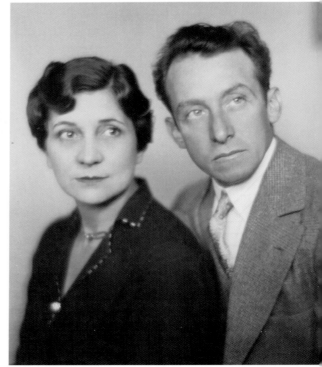

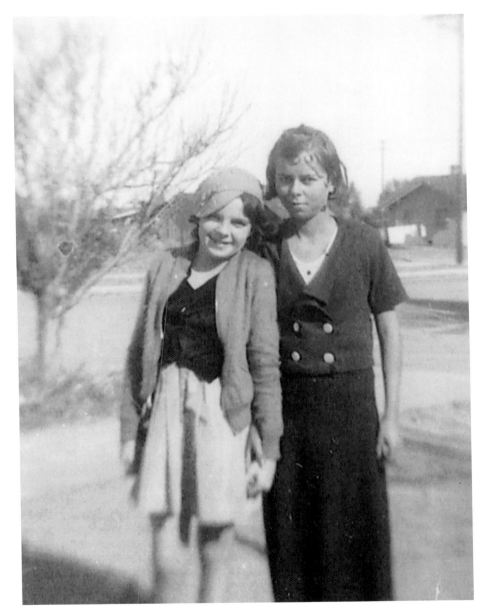

Judy Garland
Frances "Baby" Gumm (left), pictured with Esther Story, became the actress Judy Garland (1922–1969), who is best remembered for her roles in *The Wizard of Oz* and *A Star is Born*. Judy and her talented family resided in Lancaster from 1926 to 1933. Her father, Frank, leased the old Lancaster Theater, where his daughters, the Gumm Sisters—including Mary Jane and Virginia—would sing and dance between movie reels. Although all three Gumm sisters were very talented, residents claimed that "Baby" had more energy and vitality; she was also the smallest, cutest, and loudest. Judy attended Lancaster Grammar School on Cedar Avenue and was always busy singing and performing at valley-wide functions. After her career took off, she returned only once to Lancaster—in a limousine—to visit friends. (Courtesy of Irma "Babe" Story.)

Jirí "George" Voskovec

Voskovec (1905–1981) was a beloved Czech actor and playwright during the 1920s and 1930s. He had to leave Czechoslovakia twice, first to escape the Nazis, then, later, the communist regime in Czechoslovakia forced him to leave again. Voskovec was detained by immigration officials at Ellis Island for 11 months for alleged communist sympathies. His case incensed people, and no charges were filed. He became an American citizen and appeared in many television shows and in 72 movies. His most famous American movie was *12 Angry Men*, in which he played juror No. 11. In 1979, Voskovec moved to California. He had always wanted to live where real cowboys—like the valley's pioneer cowboys shown here—roamed, so he settled in Pearblossom, which had many modern-day cowboys.

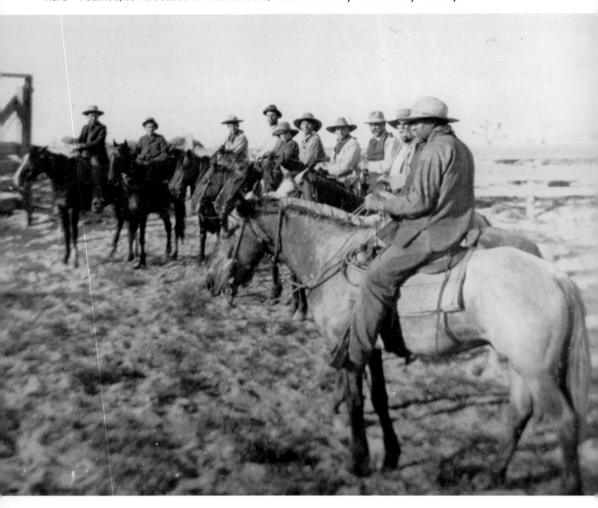

John Wayne, "The Duke"

Born Marion M. Morrison, John Wayne (1907–1979) was about six years old when his family homesteaded just south of the site of the present-day Lancaster UPS facility in late April 1914. Wayne attended the Lancaster Grammar School on Cedar Avenue. In the schoolbook shown here, the young Morrison's infrequent attendance record stands out. After less than one year, the Morrison family moved to Glendale. (Courtesy of the Lancaster School District.)

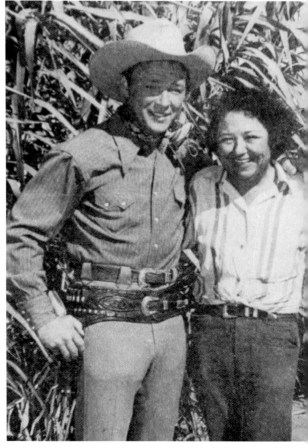

Roy Rogers and Dale Evans

In 1941, Roy Rogers (1911–1998) and Dale Evans (1912–2001) first met at Edwards while performing at a USO show. They married in 1947, and the "First Family of Singing Cowboys" purchased their Sky Haven Ranch at Lake Hughes. They had this home for only about a year. Later, the couple purchased the former house of Noah Beery—another valley resident—in Hollywood. Roy Rogers is shown here with aviatrix Pancho Barnes.

Juanita Nuñez Crothers

Juanita Crothers (1922–1993) moved to the valley in 1950, where her husband, Wilbur James Crothers (1911–1998), founded *Desert News Company*. During her 43 years as a Lancaster resident, she consistently promoted the visual arts. An artist of floral, still life, and landscape painting, she was basically self-taught; however, she attributed noted artist Walt Lee as her greatest mentor. Crothers served as director of the Antelope Valley Allied Arts Association Art Gallery from 1965 to 1969. She later purchased the Lancaster Fire Station Company No. 33 building (dating to 1929) and operated the Crothers Fine Art Gallery there. The space provided local artists with community exposure. From the 1950s until her death, Crothers served as the chairperson of the Antelope Valley Fair Art Show, supervising the hanging of more than 500 paintings each year. (Courtesy of Lynn Crothers DuPratt.)

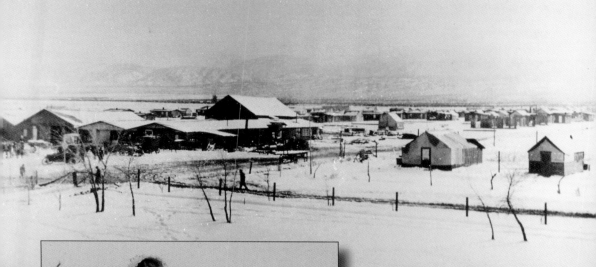

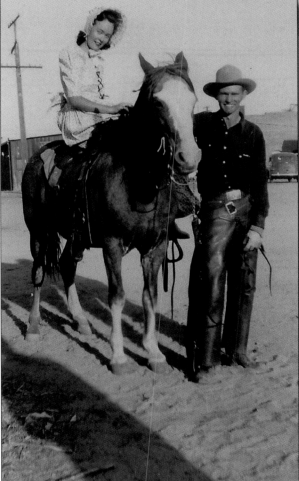

Robert "Freddie" Moore
Moore (1911–1950) spent his early childhood at the Llano del Rio Cooperative Colony (shown here). A born animator with no formal art training, he went on to become one of Walt Disney's leading artists. He was involved with most of Disney's leading characters and productions, including Mickey Mouse, Snow White and the Seven Dwarfs, Pinocchio, and Dumbo. He was ranked number four among the "50 Most Influential Animators in Disney Studio History" by Grayson Ponti.

Daniel Pierce
A shy but artistic cowboy lad who grew up with saddles and spurs in Pearland, Daniel Pierce (1920–present) became a University of Wisconsin art professor and an internationally known artist specializing in painting, drawing, linoleum prints, and woodblocks. In 1959, he became an artist-in-residence at the University of Alaska–Fairbanks. His work has been exhibited worldwide. He is shown here with Zenita Stark. (Courtesy of Milt Stark.)

Bella Lewitzky

The daughter of Russian immigrants and the legendary doyenne of modern dance on the West Coast, Bella Lewitzky (1916–2004) was born at the Llano del Rio Cooperative Colony. She claimed to have been inspired by the colony's social and political ideals. She was the recipient of numerous honors during her 60-year career. Here, Lewitzky (left) is posing with actress Beah Richards (right) and Patricia Paige. (Courtesy of Patricia Browning Paige.)

Ethel Webb

Ethel Webb (1897–1966) joined the Los Angeles–based Busch Orchestra while in high school. During weekends, the band would travel to the valley, playing from Lake Hughes to Tehachapi. She met her husband, Harry Webb (1893–1973), a former high school classmate, in Rosamond. In Lancaster, she formed her own local dance band and became a piano teacher. Webb (center) is shown with two unidentified men. (Courtesy of Barbara Webb Ralphs.)

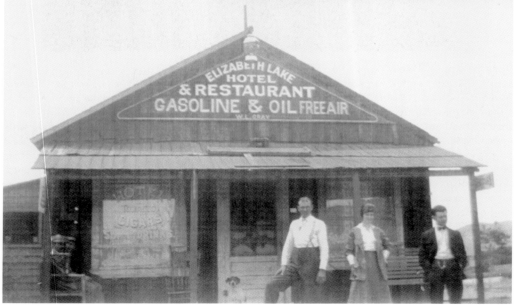

Donald "Captain Beefheart" Van Vliet

Born in Glendale, Donald Van Vliet (1941–2010) grew up an artistic prodigy. When he was 13, his family moved to Lancaster. While an intermittent student at Antelope Valley High School, he became friends with fellow musician Frank Zappa and joined the Blackouts. Van Vliet's father was a Helm's Bakery truck driver; sometimes, Don helped out and took over the route. Don's car was a blue Oldsmobile with a homemade werewolf sculpture on the steering wheel. During his teen years in Lancaster, he liked hanging out at Gilbert's 5-10-25 Cent Store, where he would purchase the records no one else wanted, for 10¢. He later enrolled as an art major at Antelope Valley College, but after one semester, he dropped out in favor of music. In the early 1960s, Van Vliet moved to Cucamonga to work with Frank Zappa, but the two separated due to musical differences. He returned to Lancaster, adopted the Beefheart stage name, and formed the first Magic Band in 1964. Soon after, he released an updated version of Bo Didley's "Diddy Wah Diddy," which became a regional hit in Southern California. His widely acclaimed album *Trout Mask Replica* (1969) featured the Magic Band, which was made up of other talented valley musicians. This album, ranked No. 60 on *Rolling Stone*'s 2012 list of "The 500 Greatest Albums of All Time," was produced by Zappa. Van Vliet retired from the music industry in 1982, but he could still be seen hanging out at the valley's Smoke Eye Lounge during the 1980s on jazz nights. A self-trained artist, he then began exhibiting his semi-abstract artwork throughout the United States.

Francis "Frank" Vincent Zappa Jr.

Grammy winner Frank Zappa (1940–1993) was one of the most exotic, original, and complex figures to have emerged from the rock culture. He was a musician and composer who experienced international fame with his band, the Mothers of Invention, and produced nearly 60 albums. Around 1957, when his father was hired as an engineer at Edwards, the family moved to Lancaster. Although usually described as a loner and a rebel—some residents have labeled him the "James Dean of the Antelope Valley"—who had difficult times at Antelope Valley High School, he did get involved in various activities. His music teacher, Mr. Ballard, sometimes let him conduct the school orchestra, but he later kicked Zappa out of the school band for smoking while wearing his uniform. Zappa formed the Blackouts, which was the only R&B band in the western Mojave Desert at this time. He played harmonica, drums, and guitar in the band. He also liked writing classical music. The Blackouts played for only one school assembly, and never at nighttime dances, as some teachers thought the band's music was too suggestive. The Blackouts appeared several times at the fairgrounds—with the sheriffs cruising by. He formed another band, the Omens, which was sometimes sponsored by the American Legion Hall Post No. 311 and played at the Lancaster Woman's Club and at the fairground's exposition hall. Zappa worked part-time in the Record Den on Sierra Highway; his bedroom was full of albums and 45s. He often joined his friend Donald Van Vliet for a late-night coffee at Denny's (now the Village Grill) on Sierra Highway. He developed a strong interest in graphic arts. Zappa made the local news in April 1958, when he won a statewide art competition sponsored jointly by the California Federation of Women's Clubs and the Hallmark Greeting Card Company. An abstract painter, he displayed artwork at the Sands Bowl and the Lancaster Woman's Club building. A 1958 Antelope Valley High School graduate, Zappa briefly attended Antelope Valley College—as he said, "Only to meet girls." One of his later songs, "Village of the Sun," mentioned Sun Village and Palmdale. A Quartz Hill power station is named after him. This photograph shows Zappa, on the drums, playing with the Blackouts. (Courtesy of Patrice "Candy" Zappa.)

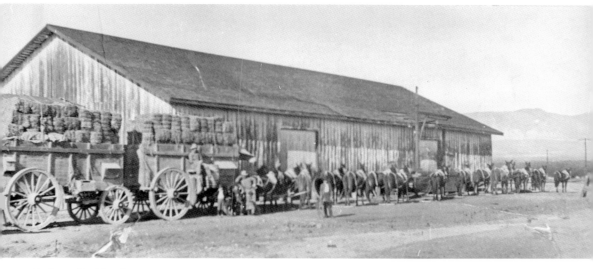

Robert R. Charleton

Perhaps the least-known heroes of the Old West are the uncredited pioneer photographers. Fortunately, much is known about the Antelope Valley's earliest photographer, Robert R. Charleton (c. 1832–?). Born in England, he lived in Mojave beginning around 1880. In addition to being a clerk and photographer for John Searles's San Bernardino Borax Company, he was a stable keeper and an early Mojave postmaster. Charleton took this 20-mule team photograph in Mojave c. 1882.

Frank Stubbings

Although there were talented photographers before him, none have the reputation earned by Frank Stubbings (1917–2005). He was the valley's most experienced studio, aerial, and freelance photographer. During his 59 years in the area, he took thousands of photographs for thousands of customers and occasions, including portraits, weddings, natural disasters, the Old Timers' Reunions, landscapes, community events, the valley's fairs, and even booking shots at the Lancaster sheriff's station. (Courtesy of Karla Archuleta.)

91

Rose Nys de Haulleville Wessberg

A resident of Pearblossom, Rose Wessberg (1908–1999) was born in Belgium, where she became an apprentice to the well-known Dutch photographer Matthew Koch. At the beginning of World War II, she married Baron Eric de Haulleville in Bruxelles, but, shortly after the birth of her daughter Olivia, the family had to leave Belgium. They traveled to France, where, due to the difficult wartime journey, her husband died. Rose later married an American interior decorator, William Wessberg, in France. The Wessbergs eventually immigrated to the United States as refugees. After Rose had a second child, Siggy, they settled in Pearblossom to be close to her sister Maria and her husband, Aldous Huxley, who lived in nearby Llano. Huxley was the English novelist, essayist, poet, and critic who wrote *Brave New World* (1932), among other works. In fact, all of Rose's sisters had married artist husbands. Suzanne married the historic stained-glass master of the Netherlands, Joep Nicolas, and Jeanne was married to G. Neveux, the French filmmaker of *The Diary of Anne Frank*. While residing in the Antelope Valley, Rose became friends with other artists and established an excellent reputation for her photographic work. She took photographs of valley residents and of more famous people, such as the composer, pianist, and conductor Igor Stravinsky, and George Balanchine, one of the 20th century's most famous choreographers. She also created a wonderful marionette theater, performing at schools, nursing homes, and different functions across the valley. Huxley, who sometimes drew, once won a prize at the Antelope Valley Fair for a pen-and-ink drawing; however, when he was listed as a winner, it was as "Mr. Huxley, the brother-in-law of Rose de Haulleville," as she was the person everyone knew! For Christmas in 1944, Huxley presented Rose's daughter Olivia with the short story "The Crows of Pearblossom," which mentioned her brother and herself as well as their neighbors, the Yosts. This book was the only children's story ever written by Huxley. At neighboring Saint Andrew's Abbey, Rose became close friends with many of the monks, some of whom were Belgian. The abbey became her second home, and she later ran its ceramics department. Rose is buried in the cemetery at Saint Andrew's Abbey. Shown here are Rose (left), Siggy (center), and Olivia. (Photograph by Joe Carrier; courtesy of Rose, Siggy, and Olivia Wessberg.)

Otis Milton "Milt" Stark

Friends of wildflower expert, community activist, and amateur botanist Otis Stark (1921–present) claim that he can identify plants from a car moving at 60 miles an hour. Stark's family moved from Texas to the Antelope Valley in 1923, settling in Wilsona. Since that time, Milt has lived in Palmdale, Pearland, Leona Valley, and Lancaster. He is a 1938 graduate of Antelope Valley Joint Union High School and a 1940 graduate of Antelope Valley College. After his World War II Air Corps service and graduation from USC, he worked for nearly 30 years with the Los Angeles County Probation Department, serving as a director of juvenile work and probation camps from Lake Hughes to Big Rock Creek. In 1968, Stark was appointed to the Westside School Board of Trustees. He served 12 years and was president four times. He was president of the Antelope Valley Trustees Association for three years. The board meetings took place in a familiar setting: Esperanza School, which he attended from the first through fifth grades. He sat about six feet from where he had sat in the fifth grade. Because of his service to the community while on the board, the trustees named the building at Seventieth Street West and Avenue G the O. Milton Stark Administrative Center. In 1972, he became involved in volunteer organizations, working with the State Department of Parks and Recreation and the Sierra Club. In 2000, he was elected president of the Poppy Reserve–Mojave Desert Interpretive Association. For his work at the Arthur Ripley Desert Woodland Park, the parks department awarded him the Medallion Award, the highest award given to volunteers. Stark's experience in his high school camera club sparked his lifelong interest in photography. A photographer of Antelope Valley wildflowers since 1969, he has published two books, *A Flower-Watcher's Guide to Antelope Valley Wildflowers* (1991) and an updated version of this book, *A Flower Watcher's Guide to Wildflowers of the Western Mojave Desert* (2000.) The satisfaction he has received from the response to these books is second only to the satisfaction of seeing his four children and 10 grandchildren having successful lives. A respected historian, Stark has served on the executive board of the West Antelope Valley Historical Society for 25 years and edited two volumes on valley history. (Courtesy of Milt Stark.)

Jane Seymour Pinheiro
Pinheiro, the "Great Poppy Lady," was a wheeler-dealer who knew how to get things done. An artist and a wildflower conservationist, she devoted her time and energy to calling attention to the valley's wildflowers and ensuring that they were protected for future generations. Pinheiro (1907–1978) moved to the Antelope Valley in 1940. For almost 40 years, she belonged to more than 50 different organizations.

Charles Samuel LaMonk
Artist Charles LaMonk (1910–1990) is noted for his sensitive renditions of the Tarahumara Indians at Copper Canyon, Mexico, and his contributions to archaeology and anthropology. LaMonk studied and reproduced realistic pictographs and petroglyphs—Native American rock art. He moved to the valley in 1955, attracted by the area's abundance of pictographs and petroglyphs, which aided his artistic endeavors.

Donald "Don" Imus
Syndicated radio personality Don Imus (1940–present) left his railroad job and began his disc jockey career in Palmdale. In 1968, he was making $80 a week at radio station KUTY. Listeners—including his friend "Captain Beefheart" Van Vliet—called his morning show "Captain Don's Slander Hours." After several career moves, he eventually made his way to New York City, where he became an influential figure in broadcasting.

Dean Roper
From the early 1950s to the mid-1980s, Dean Roper (1926–1998) was one of the valley's premier radio broadcasters. He began his career at KAVL. With his "big" voice, he was continuously in demand as the master of ceremonies for numerous civic and service banquets and functions. He provided live coverage of high school and college football and basketball games and was an announcer at the Antelope Valley Fair. Roper is pictured with coworker Patricia Paige. (Courtesy of Patricia Browning Paige.)

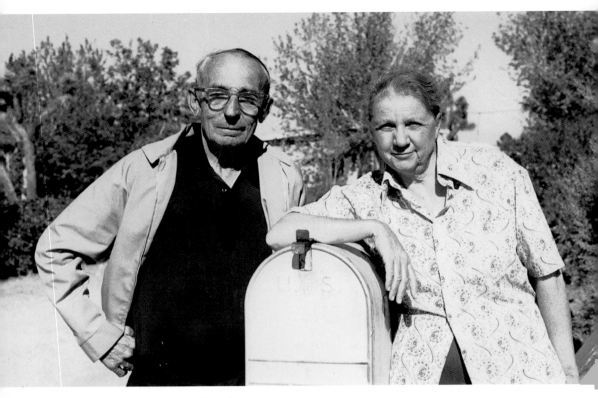

Leigh Douglass Brackett Hamilton

Born in Los Angeles, Leigh Hamilton (1915–1978) was one of the more talented and influential writers in the field of science fiction and fantasy literature, especially romantic space epics. She earned the title "Queen of the Space Opera." She also wrote mystery and crime novels, more than 200 short stories, and was a notable screenwriter. She wrote screenplays for several highly acclaimed films by the director Howard Hawks. Being a female writer at the time was not easy. Hawks hired her to write the screenplay for Raymond Chandler's *The Big Sleep* (1946) along with William Faulkner and Jules Furthman. While Furthman was nearly 60, Hawks was quite surprised when he discovered that Brackett was a 28-year-old female. She did most of the writing, but only received $600 per week, while Furthman was paid $2,500. She also cowrote the movie scripts for *El Dorado, Rio Lobo, Hatari,* and *Rio Bravo,* all which starred John Wayne, an early valley resident. During the 1950s, she tried her hand at writing scripts for television series, such as *Alfred Hitchcock Presents, Checkmate,* and *Suspense.* In 1973, she wrote the screenplay for Robert Altman's film *The Long Goodbye.* She married science fiction writer Edmond Moore Hamilton (1904–1977) in 1946; Ray Bradbury, their lifelong friend, served as best man. The Hamiltons maintained two residences: Edmond's home outside of Kinsman, Ohio, and a winter house in Lancaster, which they purchased in 1968. Brackett died in her valley home while she was finishing the first draft of the screenplay for *The Empire Strikes Back* for George Lucas. At the time, she did not receive credit for the final script because Lucas did not like it. In 1980, she received a posthumous Hugo Award for the film. This photograph of Leigh and Edmond was taken at their Lancaster home by their friend, Swedish journalist, editor, and mystery writer Bertil Falk, when he visited them in the 1970s. (Courtesy of Bertil Falk.)

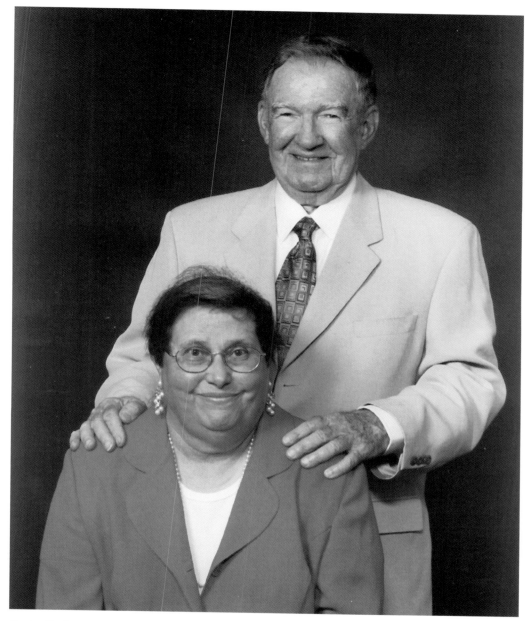

Katie Corbett

A retired business editor for the *Antelope Valley Press*, busy Katie Corbett owns a public relations business. She was a technical editor at Lockheed, a public information officer for the Lancaster School District, edited books, and authored a book. She served for 25 years as the public relations chairwoman for the Antelope Valley Board of Trade and was named a lifetime director. Her many honors include nine national newspaper awards; Regional Small Business Administration Media Advocate; a state school publication award; and being named the Most Cooperative Newsmaker by the *Antelope Valley Press* Club. She is also a past president and a 43-year member of the Antelope Valley Branch of the American Association of University Women. Corbett is pictured with her husband, Carroll. (Courtesy of Katie Corbett.)

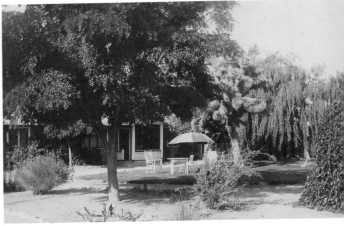

Carlyle Ellis
Canadian-born Ellis (1875–1942) was known as the world's foremost producer of nontheatrical health and social service films. His clients included the Children's Bureau of the US Department of Labor, the Tuberculosis and Health Association, and the YWCA. When his health declined in 1939, he moved to Henry Menning's Palmdale Casa del Adobe (right), where he worked for the *Hollywood Reporter* and wrote three novels and valley articles.

Kay Pedersen Ryan
A college English instructor and author of six poetry books, Kay Pedersen Ryan (1945–present) was introduced to poetry at Antelope Valley College. In 2008, she was named the nation's 16th Poet Laureate Consultant in Poetry to the Library of Congress. Ryan also received the 95th annual Pulitzer Prize in Journalism, Letters, Drama, and Music for her work *The Best of It: New and Selected Poems.* (Photograph by Christina Koci Hernandez; courtesy of Antelope Valley College.)

CHAPTER SEVEN

Businesspeople

For many veteran residents, their nostalgia is tied to some of the valley's former businesses that today are just a memory.

Mojave was the first Antelope Valley community to have a downtown shopping area, but, through the years, each community developed its own business hub. Lancaster became the "Heart of the Antelope Valley" during the 1920s, as it was the place where residents from all communities would travel to in order to conduct major purchases. The trip became an all-day shopping adventure as well as an occasion to visit friends and catch up on the latest news.

Besides the Southern Pacific Railroad, a national company, which has been taken over by the Union Pacific, the valley's oldest family-owned businesses are the Stephen B. Marvin Insurance Agency and Stephen B. Marvin Real Estate, Inc., in Lancaster, which celebrated its 100th anniversary in 2012. In addition, the Lancaster Mumaw Funeral Home is over 100 years old. Some businesses have been serving loyal patrons for 60 years; some, however, lasted only a few months.

The Chinese laundry man was an American phenomenon. Several Chinese laundries operated in old Mojave, but the most popular one was owned by On Lee in Lancaster.

Lucy Angell, Effie Corum, and Margarita Hefner served as postmistresses. This was one of the earliest federal government jobs open to women. Women usually owned general merchandise stores or inns. Mojave's "Ma" McDonald ran the Los Angeles Rooming House.

The businesses of early well driller Frank Rottman and automobile dealer H.W. "Hank" Hunter have continued with their sons and grandsons. These establishments have served generations of customers. Barber Hugh Badgley attracted attention not for his hair-cutting techniques, but instead for his lack of footwear. Through the years, many valley homes have been furnished with items from longtime furniture stores Aven's and Sperlings.

Confectionery owners, florists, printers, waitresses, pharmacists, clothiers, hardware store owners, frontier newspaper editors, and real estate agents have all contributed to the Antelope Valley's business community.

Lucy Angell

In 1919, Lucy Angell (1883–1968) and her husband, Ralph, arrived in Rosamond, which at the time boasted 35 residents. Soon after, she was appointed postmistress. In 1934, a fire destroyed the general store, which contained the town's library and post office. These facilities were then housed in the Angells' living room and dining room. It was intended as a temporary arrangement, but they remained there for 33 years, until Angell retired.

Aven's Furniture

Aven's Furniture has been a fixture in downtown Lancaster since 1937. A family business, it has moved three times and has been in its present location since 1951. The store was started by Budd L. Aven, whose father, H.B., came to the valley in 1928. In 1974, Robert Turner (shown here) started working at the store after school. In 1988, he acquired the business, which continues to serve generations of customers.

Now Open

HUGH'S BARBER SHOP

at

1025 Beech Street

WILL CONTINUE AS USUAL

Hugh Banks Badgley
Badgley (1886–1982) was "Lancaster's barefoot barber." He found wearing shoes too uncomfortable. In 1930, Badgley, a former farmer, became a barber. A state inspector told him he would revoke Badgley's license if he continued not wearing shoes at work, so Badgley started wearing unlaced floppy shoes or sandals without socks. Badgley died at age 96. He was riding his bicycle on Lancaster Boulevard when he was hit by a car.

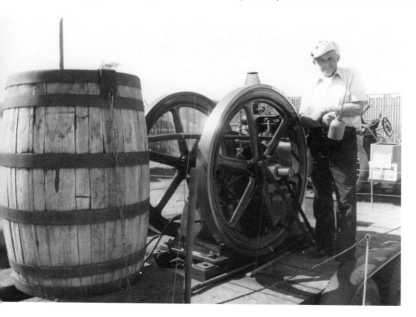

Carl Bergman
A 70-year Antelope Valley resident, Carl Bergman (1907–1999) was known as the king of old cars. A former resident, in 1933, he returned to the valley driving a Model A Ford roadster. He refurbished gas stations, served in the US Air Force, operated an equipment rental yard, and built more than 500 hay barns. In 1997, he was inducted into the National Hall of Fame of the Early Day Gas Engine and Tractor Association.

Max Harold Carol

To evade a compulsory 25-year service in the Russian military, Max Carol (1891–1970) left Poland in 1913 to come to America. He eventually made his way to San Francisco, where he was a salesman at the Emporium. In 1936, he moved to Mojave and opened a popular clothing store under the Alton-Kingston Hotel. As the Depression was in full swing, most of the customers were gold miners and railroad workers. The miners did not make much money, and most of the railroad workers were spendthrifts, so Carol's business was thin at times. But Carol's Store, "the friendliest store in the desert," became known for providing the best merchandise in town. He was a tireless businessman and community leader. He helped organized the Mojave Chamber of Commerce and was the first president of the Mojave Businessmen's Association. He started the American Legion Club and the Lions Club, and he strongly supported the Boy Scouts and Little League events. He was also in charge of several Mojave Gold Rush Days celebrations. He and his wife, Pauline, were always pitching in for a better community. A Jewish veteran of World War I, Carol was a strong supporter of several veterans' organizations. Beginning during World War II, the draft board was located in his store until the Vietnam War. Sadly, his sisters, Bronia and Esther, were both killed in German concentration camps. Carol's son, Cyril, operated the family business as a Western-wear clothing store beginning in 1954, until it closed in 1995.

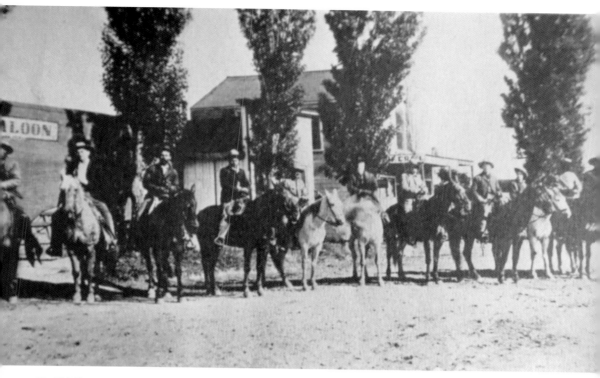

Del Valle and Cram Families

The Del Valle family was one of the wealthiest, oldest, and most respected families in Southern California. Antonio Del Valle was granted the 48,000-acre Rancho San Francisco–Francisquito in 1839. After his death in 1841, gold was discovered there in March 1842 by Francisco "Cuso" Lopez. Don Ygnacio Del Valle, who became the *alcade* (mayor) of Los Angeles, was now the ranch's owner. The Del Valles' ties to the Antelope Valley began in 1843, when the government granted Rancho Tejon to Ygnacio as a reward for his valued military service under Gov. Jose Figueroa. The Del Valle family was also associated with the famous Rancho Camulos adobe near Piru and Fillmore; it had originally been part of the Rancho San Francisco. Author Helen Hunt visited the rancho briefly in 1882, and probably based her fictional character, Ramona, on a composite of two young girls living there. In 1896, at Rancho Camulos, Ysabel "Belle" Del Valle (1868–1936), daughter of Don Ygnacio Del Valle and Doña Ysabel, married Charles H. Cram (1863–1924).

Originally from Chicago, Cram was a homesteader from Fairmont, about 30 miles away from the family's ranch. He became a leading Antelope Valley merchant. He first had a general merchandise store in the Fairmont area (1895), which his brother Rupert later managed. Cram also planted some of the valley's first apple orchards (45 acres). From 1904 to 1912, he owned the Cram General Merchandise Store in Lancaster near the northwest corner of present-day Lancaster Boulevard and Sierra Highway. Charles's brother Walter, who married Ysabel's niece Eliza "Nena" Clotilde Nepumocena Del Valle (1873–?) also at Rancho Camulos, supervised this store. Charles and Ysabel lived on the second floor of this building. They had one daughter, who was also named Ysabel. During this period, Charles strongly promoted the construction of the Los Angeles Aqueduct, selling supplies to the project's workforce. Belle was involved in many community events and enjoyed being in charge of women hunting rabbits during the valley's numerous early rabbit drives. Their store burned down in 1912, and the Cram family went to live in Los Angeles with one of Ysabel's sisters. But they continued to visit Lancaster. Charles died in the Palmdale Inn. In this 1912 photograph, the Crams' general store, the third building from the left, is located behind the cowboys.

Deaver Family
All five members of the Deaver family have made their mark on Mojave by devoting their lives to community service. Paul (1905–1995) and Marion Mack (1907–1999) moved to Mojave in 1948. Paul, who was in the retail gas business, came here due to his asthma. He purchased two Shell gas stations and the Shell bulk plant. He was also in charge of fuel supplies at the Marine Corps Air Station–Mojave during the 1950s. Active in community organizations, he served on the Desert High School District Board to develop east Kern County's first high schools. Marion, a graduate of Stanford University, was a former southeast Kern correspondent for the Bakersfield *Californian*. When her son William and his wife, Billye, purchased the *Mojave Desert News*, she wrote for it. She loved the region's rich history and interviewed many pioneers. Marion also operated an early flower shop and was active in local service organizations. Their son William "Bill" (1935–present), an Antelope Valley High School graduate, has been active in many venues, including as a photographer, the former editor-publisher of the *Mojave Desert News*, serving on the staffs of two members of Congress, and as a California state assemblyman. He has held positions in the administrations of Presidents Ronald Reagan and George H.W. Bush, with his brother Michael's public relations firm, and as a Mojave constable. A past president of the Mojave Chamber of Commerce, Bill has served on regional health care, historical, and pollution control boards. Michael "Mike" (1938–2007), a Desert High School graduate, at one time flipped hamburgers at the Burger Spot. He later became known as the "Media Maestro," working for Governor Reagan and, later, President Reagan. He shaped Reagan's public image and forever changed the way presidents are presented. He is the only Antelope Valley resident to have served on a White House senior staff. Susan Wiggins (1950–present), a graduate of Mojave High School and a Mojave Unified School District retiree, also worked as a newspaper reporter and served on the boards of the East Kern Airport District and the Mojave Unified School District. She is currently a Tehachapi City Council member. The Deaver siblings shown here are, from left to right, Susan, Michael, and William. (Courtesy of the Deaver family.)

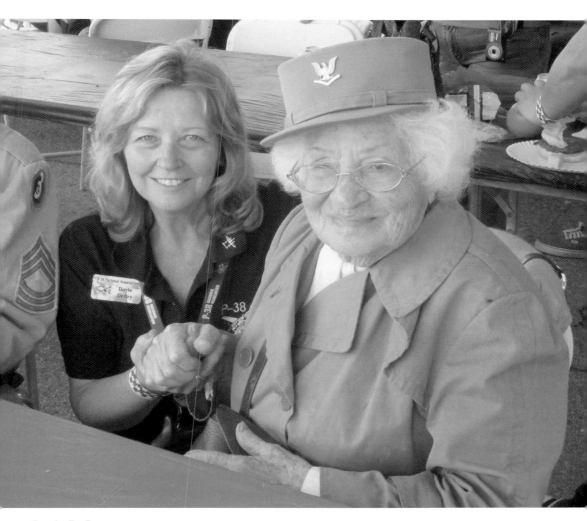

Dayle DeBry

Dayle DeBry's work with veterans—past and present—is appreciated community-wide. She moved to the valley in 1979 and, after several positions, became an employee at the historic Lancaster Cemetery. She started as a historian and marketing representative and became the cemetery's full-time manager in 2008. DeBry (1955–present) is a West Antelope Valley Historical Society volunteer-director and a founder of the Friends of the Lancaster Cemetery, Inc. The committee works to present special events and preserve and erect the cemetery's historical monuments. She has written a well-received book on the valley's World War II veterans. DeBry is also president of the P-38 National Association, which works to preserve the history of World War II–era planes, pilots, and crews. She is pictured attending an event with 102-year-old Bea Cohen, the oldest female Army veteran, in 2012. (Courtesy of Dayle DeBry.)

John DeWolfe Lumber Company

During the early 1950s, John DeWolfe (1926–2010) was a Quartz Hill chicken rancher by day; at night, he laid wooden floors until midnight. In 1951, when Georgia Pacific Lumber offered him a temporary valley job selling lumber to farmers, he took it. Having done well with his loyal customers, DeWolfe (left) opened a small store in rural Quartz Hill in 1952, expanding it three times. Cesar Portillo, who had extensive experience with his family's Los Angeles lumber business, bought the DeWolfe store in 2007 and today continues the business. The below photograph shows the store's present staff, Cesar Portillo and Brightie Smith. (Left, courtesy of Frances DeWolfe and Frances Lane Hughes.)

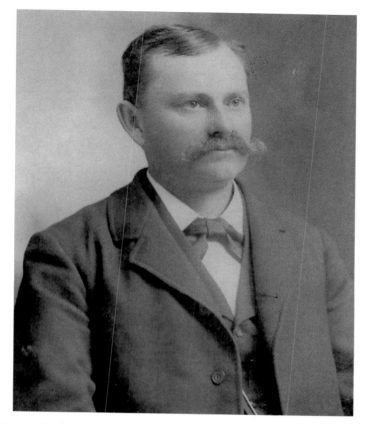

Charles Waldemar Dodenhoff

Charles Dodenhoff (1854–1948) emigrated from Germany to New York in 1872 and moved to Pennsylvania, where he married Lina Zirkel in 1878. They moved west and settled in Oregon in 1886. However, his wife contracted tuberculosis, and the doctor said she needed to live in a drier climate, so in 1888, Dodenhoff traveled by train to Harold and then by wagon to Palmenthal–Old Palmdale, where he purchased some property. Sadly, by the time he returned home, Lina was worse, and died shortly thereafter. He married a 19-year-old neighbor girl, Hulda Lavina Kimsey, two months later, and they moved to Palmenthal with his three children. In his diary, Dodenhoff claimed to "have brought three colonies of people [probably Germans] from the East to settle in Palmdale, and was proclaimed the father of that region." Dodenhoff lived in both Old and New-West Palmdale for about 15 years. His many valley occupations included real estate agent, lumber dealer, secretary and board member of the Palmdale Irrigation District, community news reporter for the *Los Angeles Herald*, census taker, notary public, justice of the peace, deputy assessor, and voting inspector. He became a close friend of Spencer G. Millard, an attorney for the Palmdale Irrigation District, who served as the lieutenant governor of California from 1895 to 1899. Dodenhoff fathered 13 children, 6 of whom were born in Old Palmdale. One son, Charles Wilbur, died as a toddler and was buried in the Dodenhoff's backyard. On a happier note, one of Dodenhoff's descendants was told by Palmenthal pioneer Mrs. Nagel that he enjoyed driving down the streets in his fancy surrey and giving the neighborhood children rides. As Dodenhoff had many real estate connections, one of his daughters, Una Helene (1895–1966), may have had the Palmdale-Harold Una sag pond named after her. There is also the possibility that the pond's name was in honor of another resident, Una Cole. Due to the drought at the end of the century, the Dodenhoff family left Palmdale. Charles moved to San Bernardino, Sebastopol, and eventually returned to Oregon, where he became a justice of the peace and, later, died in Grants Pass. (Courtesy of Charlene Dodenhoff Patterson.)

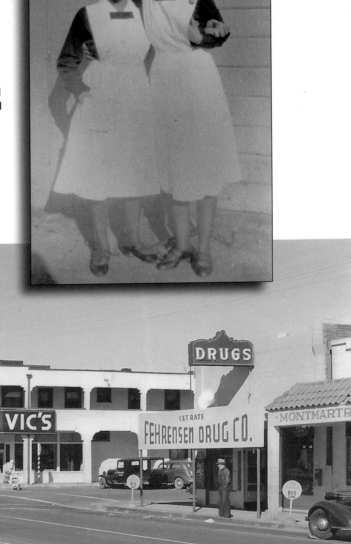

Ella Roe Drinnon

Ella Drinnon (1909–1996) encountered many hardships while growing up in Kansas. She went to the Kansas City Harvey House office to apply for a job and was given three cities to choose from. She selected the only California city on the list, Mojave. Drinnon stayed there from 1931 to 1933. A Harvey Girl for 10 years, she worked at different locations. Drinnon (left) poses with Mildred Alden outside the Mojave Harvey House.

Fred Fehrensen Jr.

Fehrensen (1891–1975) was a prominent valley pharmacist from the 1920s to the late 1940s. He moved to Palmdale in 1918, where he clerked for Dr. Jones, who owned the local drugstore. In 1925, Fehrensen purchased the store. Many early residents say he had the Antelope Valley's best soda fountain. Fehrensen sold the business in 1934 and moved his store to Lancaster and then to Mojave, shown here.

Orson and Minerva Folgate

As Orson Folgate (1879–1960) had asthma, he and his wife, Minerva (c. 1884–1964), moved from Missouri to Los Angeles. There, they met Mr. Hudson, who introduced them to the Antelope Valley. Around 1916, the Folgate homestead was located at Avenue O and 200th Street East in the Lovejoy Springs area, which now is Lake Los Angeles. Their homestead covered 300 acres. Orson, who was a surveyor, did some dry farming and regulated the water flow at Lovejoy Springs once a week with a flowing dyke. Busy Minerva sold produce, chickens, and their fertilizer to Los Angeles businesses. A good businesswoman, she began socking away the money from this enterprise to use for future ventures. Around 1918, when Mr. Hudson, who owned the nearby Rockpile Ranch, offered to sell it, Minerva jumped at the opportunity to purchase the property, where they later raised their three daughters, Crystal, Liberty Bell, and Wilma "Wink." During this period, Orson helped Arden Edwards construct what was to become the nearby Antelope Valley Indian Museum. All went well until the 1930s, when a fire destroyed their home. The family moved to Valyermo, where Orson managed the apple farm, which is now St. Andrew's Abbey. During the 1940s, the Folgates opened several businesses with daughters Liberty Bell and Wink on the north side of Palmdale Boulevard, between Eighth and Ninth Streets East. From west to east, there was a boardinghouse, the Gas Company, Palmdale Dress Shop, Palmdale Beauty Salon (where daughter Crystal worked as well), and Radio Palmdale, which was owned by Liberty's husband, Milton Wolf. Minerva, Liberty Bell, and Wink drove to Los Angeles in their little Austin several times a month to purchase high-quality ladies clothing for the Palmdale Dress Shop. The Folgates were always involved in community organizations. Orson served on the Wilsona School Board and was an air-raid warden during World War II. Wink and Liberty Bell were "USO Girls" during World War II and, later, members of the Palmdale Chamber of Commerce. Around 1950, the Folgates returned to their beloved Rockpile Ranch. The family still resides at the almost 100-year-old ranch. Shown here standing in front of the family stores are, from left to right, Wink, daughter Charlene Taylor, grandchild Gina (in front of Charlene), Liberty Bell, and Angie Valdez. (Courtesy of the Folgate family.)

Murl Genrich
A 20-year resident of the valley, Murl Genrich (1888–1930) resided in Redman, Willow Springs, and Mojave. Always involved in community activities and helping others wherever he lived, Genrich enjoyed performing with the Willow Springs Dramatic Club. During the 1920s, he operated a soft drink and gas station business in Mojave. Genrich (left) is shown standing with Roy Driscoll (center) and Sam Walker in Willow Springs.

Bertram Luther Gookins
Gookins (1877–1955) and his family settled in Pine Canyon near Neenach in 1891. A farmer and a dedicated mailman, he reportedly drove the country's only traveling US post office. During his two-day route, he carried mail from Palmdale to Elizabeth Lake and continued on to Sandberg before returning home. This photograph shows the Neenach Post Office and Lancaster resident George Webber and two unidentified women.

Col. Thomas Spencer "T.S." Harris

By the time Col. Thomas Harris (1836–1893) arrived in Lancaster in 1885, the *Los Angeles Times* claimed he had published more frontier newspapers than any other man in the country. Born in Ohio, he was 12 years old when he started working in the printing trade. While in Utah, he participated in several Indian engagements, and the Army recruited him to work on its newspaper. With the outbreak of the Civil War, Harris enlisted in the Sacramento Rangers, and was promoted through the ranks until he was commissioned a second lieutenant in 1862. By 1863, he was a captain with the First Cavalry, Oregon, Company A. There is no information indicating when he became a colonel. After the war, he traveled throughout the Southwest as an itinerant printer with his portable equipment, similar to the one pictured above. While working in Independence (Inyo County), he surprisingly opened a dance school, which failed. Harris next went to Sacramento and became a state legislature minute clerk. But he had acquired "Mining Camp Fever" and ventured to Panamint, Darwin, and Bodie. Harris always found himself tangled in political controversy, constantly criticized, and even threatened with death. Once, his enemies poisoned his beloved little dog, Fly; on another occasion, someone bashed his head with a six-shooter. Relocating to Southern California in 1882, he founded the *Santa Ana Standard* and, in 1883, the Los Angeles *Freelance* and the *Republican* newspapers. In 1884, he quarreled with the *Republican's* editor, Charles Whitehead, and shot him. Harris was found guilty of assault and sentenced to one year in San Quentin. However, he served only three months, as he was pardoned by Gov. George Stoneman. His next stop was the Antelope Valley. With B.C. Ferguson, Harris started the *Lancaster News* in 1885; within a month, he was the sole owner. In Lancaster, he led the Fourth of July activities, was a Lancaster School trustee, and even developed a machine for making rabbit-proof fences. In November 1886, he moved the newspaper to Rosamond and renamed it the *Antelope Valley News*. He also became the town's postmaster. But bad luck constantly followed him. When his wife died following an operation, he suspended his newspaper in April 1887. He moved to Tulare, where he founded his last newspaper. He prospered for a time, but then there were reverses, and the despondent Harris committed suicide.

John Charlton "Jack" Hart

Hart (1922–2005) had only been in the Coast Guard for six months when Pearl Harbor was bombed. He remained on a destroyer at sea in Australia and New Zealand until the war was over. After his World War II service, he traveled to the Antelope Valley in 1947 and managed one of Victor Ryckebosch's turkey farms. He immediately became attracted to the region's rural atmosphere, but, most of all, its people. He later moved to Van Nuys to learn about the printing business with his father, who owned a print shop. After Jack married Dee (1927–2012), they moved to the Antelope Valley in 1959. At first, he was working on Lockheed's F-104 aircraft, but as he had great printing skills, he decided to start a print shop. In 1960, he worked by day on aircraft and, at night, ran his new printing business, with Dee handling many details. Hart Printers moved to its current location in 1964, and the business expanded through the years. Jack always felt he was making friends—not working for them. A few of them, even when they moved to Hawaii, continued to use his services for several years. Willow Springs Race Track and Aven's Furniture have been loyal customers for over half a century. As a business leader, Hart always felt that, since the valley took care of him, it was important for him to give back to the community. He was a member of the Lancaster Elks Lodge No. 1625 for 45 years, past president of the Lancaster Rotary Club, and a director for the Lancaster Chamber of Commerce. In 1988, he received the chamber's Unsung Hero Award. He had the biggest heart and was very supportive of many athletic teams and groups over the years. He served as Lancaster's honorary mayor from 1975 to 1976. A quiet person who liked to stand in the background, Hart was very surprised when he received the Antelope Valley Corps of the Salvation Army's "Others Award," for being a model citizen and outstanding leader, the highest civilian award given by the organization. Hart's son, Donald Sr., started working side-by-side with his father when he was 12. He sold the business to Donald in 1992, and today, Donald Jr. continues the family's printing business. (Courtesy of the Hart family.)

Healy Glass

At its current site since 1970, the Healy Glass Company operates from what may be downtown Lancaster's oldest business building, which has not changed that much in appearance since it opened in 1914 as Joseph Varela's general merchandise store. In 1970, Don Healey moved his Healy Glass here, and in 1980, Choe Pyong (right) purchased the store that he runs with his son Elson.

Hurd Family

Around 1925, construction on a Lake Hughes resort project began. Fire then destroyed the buildings, which were rebuilt with local quarried rocks hauled in by Joel Hurd. The building, which opened as the Lake Hughes Trading Post, is now called The Rock or The Rock Inn. Hurd's sons Charles (1917–2001) and Joel W. (1911–1996) bought the store from their father in 1940 and took over its management until it was sold. (Courtesy of Ronald Garcia.)

William Peter "The Dutchman" Helfrich

A native of the Netherlands, William Helfrich (1876–1939) homesteaded more than 300 acres in the foothills between Quartz Hill and Leona Valley. This lifelong bachelor pioneer was a wheat farmer, almond rancher, cattleman, astronomer-meteorologist, linguist, and botanist. Well liked and an asset to his community, he assumed a Belleview School clerk position and hauled drinking water for the students and staff, as the school lacked running water. During the 1930s, he became known throughout Southern California for his success in forecasting weather months and years in advance. He claimed that his forecasts were based upon the relative positions of the earth and planets and their respective gravitational forces. Today, Helfrich's little house is on Roger and Frances Lane Hughes's property. (Courtesy of Frances Lane Hughes.)

George Hummel

Hummel (1887–1978) moved to Rosamond in 1939. He was the business manager for the Los Angeles Union Rescue Mission, which had purchased the townsite from Charles Stinson in 1916. Stinson had owned the site since 1904. Hummel helped develop Rosamond's much-needed first water system in 1935. In 1939, he purchased the mission's land. He was also instrumental in building the Wayside Chapel (shown here).

On Lee,

LAUNDRY Work done on short notice.

Lancaster, California

On Lee

In Lancaster, On Lee, who was probably a former Southern Pacific Railroad worker, ran a Chinese laundry service and sold potatoes from 1885 to the early 1890s. His store was located near the northwest corner of modern-day Lancaster Boulevard and Sierra Highway. In 1889, some residents would sit near the bank across the street and shoot jackrabbits, which they then hung on Lee's door.

H.W. "Hank" Hunter

Born an Angeleno, H.W. Hunter (1909–1996) moved to the Antelope Valley in 1929 to become a cowboy. He found work on several ranches and then took a job at a car dealership and garage owned by Chester Smith, which Smith had owned since the early 1930s. Under Smith's tutelage, Hunter learned the business and eventually purchased Smith's gas station. He transformed it into the H.W. Hunter, Inc., Dodge, Chrysler, and Plymouth dealership in 1944. A valley resident for 67 years, he was very active in the community. After World War II, Hunter hired many returning veterans. He was a past president of the Lancaster Rotary Club, Exalted Ruler of the Lancaster Elks Club, and he served on the Antelope Valley Hospital Board. Hunter helped to establish a Department of Motor Vehicles office and several bank branches in Lancaster, and he was a Community Chest board member. Hunter was an excellent horseman, the Antelope Valley Fair would not be what it is today without his decades of vital help. He was instrumental in starting its rodeo and was a major sponsor for many years, along with being a supporter of the Junior Livestock Auction. Hunter, who worked up until his death, was known not only as a successful businessman, but also as a philanthropist who donated time, money, and cars to charities and individuals in need. His numerous sponsorships included Little League, bowling, and softball teams, plus Equestrian Trails. Hunter owned his Lancaster dealership for 52 years. Currently in its third generation, Hunter's grandsons Tom and Tim Fuller continue the family business. Hunter (center) is shown with an unknown Chrysler representative (left) and manager Sam Farmer when the dealership was located on Sierra Highway. (Courtesy of the Hunter and Fuller families.)

Wesley "Wes" Spicher

A Navy lieutenant during World War II, Wes Spicher (1925–2001) and his wife, Gloria, grew up in Alhambra. After the war, Wesley's father, Elmer, who was raising orchids for civic organizations, asked them for help, and they took a floral arrangement class. As a young family, the Spichers were looking for an area with business opportunities as well as a great place to raise a family. They found their dream location when they heard there was a flower shop for sale in the high desert, and in 1953, Wes purchased the Antelope Valley Florist store on Sierra Highway in Lancaster. At the time, it was the valley's only florist store. It was hard work. Every Wednesday, Wes would make the long trip "down below" to Los Angeles in a Volkswagen van over Angeles Crest Highway—there was no freeway at the time—rain or shine, to purchase fresh flowers from Southern California growers. When the new Antelope Valley Hospital was constructed during the late 1950s, the Spichers moved their store near it. No other businesses were located there—only acres of empty land. A community-oriented person, Wes was involved in many organizations and activities. He enjoyed presenting floral displays at the Palmdale Lilac Festival and the Antelope Valley Fair. He worked with others in early attempts to get Lancaster incorporated. He was a huge YMCA supporter and was active in American Legion programs. A Lancaster Chamber of Commerce board member and president of the Lancaster Rotary Club in 1959–1960, he was also the representative for state senator John Harmer. Despite these ongoing projects, he still managed to serve on the Selective Service Board for the valley, which met in Van Nuys. The Antelope Valley Indian Museum was his last project; he was a committee member who worked to have it purchased by the state and maintained as a public museum. Spicher's son Chris took over the floral business in the mid-1980s. He worked with his brother for 13 years until Gary decided to leave and become a counselor. Posing in this happy family photograph are Gloria, Gary (center), and Wes. (Courtesy of the Spicher family.)

Kalidas "Kali" LePage

In 1923, Kali LePage's family homesteaded in Juniper Hills. After high school, LePage (1910–1988) went to India to study for the ministry, which did not work out. In 1932, he began printing the area's first newspaper—the *Foothill Sentinel*. In 1949, LePage constructed a new Pearblossom post office and served as the postmaster for over 40 years. He also established the Pearblossom Chamber of Commerce. The town's current post office is shown here.

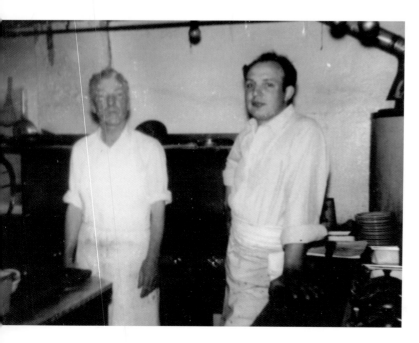

Reno Hugo Riccomini

Riccomini (1914–1971) first came to Mojave around 1924 when his father, a railroad worker, was transferred there. Reno learned to cook at the French Café, but then moved to Bakersfield. He returned to Mojave in 1941 and operated Montmarte Café. He then started Reno's, which became one of Mojave's most noted restaurants and was operated by three generations. Shown here at work are dishwasher T. Huck (left) and Reno. (Courtesy of Michael Riccomini.)

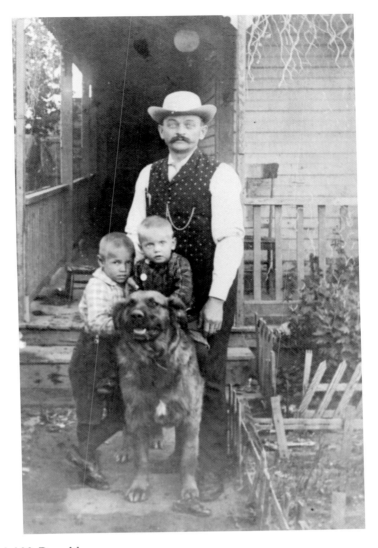

Eliza and Daniel McDonald

Born in England, 28-year-old Eliza Lillian Taylor (1878–1967) arrived in Mojave in 1905. She had been invited by her aunt, Sarah Faulkner, the owner of the Los Angeles Rooming House, to come to Mojave and stay with her. When Eliza reached Mojave, however, her aunt was dead, and she had willed the rooming house to her. Not long after settling in Mojave, Eliza met Daniel McDonald (1870–1923), a Boston shipyard worker, who had gone west to seek his fortune. He was a miner at the Exposed Treasure and Queen Esther Mines when they married in 1907. Eliza McDonald managed the hotel and restaurant, and Daniel ran the saloon. With the railroad, mines, and the construction of the Los Angeles Aqueduct in full swing, the McDonalds added on to their rooming house to take care of the increasing work crews—but Eliza rarely rented out rooms to women. Old-timers remember her as friendly but very tough. She always seemed to have a broom in her hand, busy sweeping away the never-ending dust and sand. She affectionately became known as "Ma" McDonald for her kindness; she also baked the best persimmon cookies. She operated the rooming house continuously for more than 60 years. When Prohibition shut down saloons throughout the country, Daniel became the last saloonkeeper in Mojave to close his bar's swinging doors in 1919. Daniel McDonald is shown here with his two sons, Joseph (left) and Donald. (Courtesy of Lily T. McDonald Stradal.)

Marvin Family

In 2012, the Stephen B. Marvin Insurance Agency and Stephen B. Marvin Real Estate, Inc., celebrated their 100th anniversary. The company's founder was Alice Adams Rutledge, who moved to the valley in the 1890s. Called the "Mother of the Antelope Valley," in 1912, she became California's first female licensed real estate agent. She later formed an insurance agency, which was eventually taken over by her son Frank. In 1937, Stephen Marvin took a position there, working with insurance clients, and the company later became Marvin and Rutledge. In 1951, Marvin purchased the rest of the firm, and through the years, different family members have joined it. Henry "Hank" Marvin is the chairman and chief executive officer of the third-generation business, which is now composed of two different family-run corporations. (Photograph by Ron Siddle; courtesy of the *Antelope Valley Press*.)

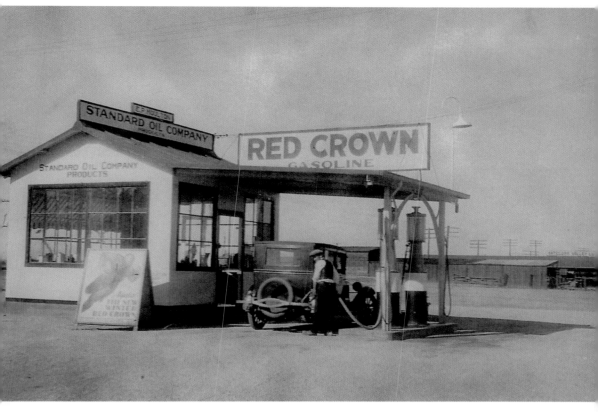

Edward Pierce Moulton Family

Kansas-born Edward Moulton (1871–1940) and his wife, Zada Belle Burkett Moulton (1873–1950), relocated to Palmdale in 1919. Soon after, he developed pear orchards on 40 acres near Sierra Highway. Wanting to expand his businesses, he opened the Palmdale-Moulton Hardware Store on the north side of Palmdale Boulevard just east of Eighth Street East, the site of the present-day Western Union. The family owned the business for many years. In addition to managing his store, Moulton also served the community as president of the all-important Palmdale Irrigation District (1921–1924). Zada also worked at the store as a clerk, and she, too, was very active in the community. She loved all of the town's special events and did her part by being a member of the Palmdale Woman's Club. One of their sons, Owen Sr., was the owner of one of Palmdale's most popular service stations, the Red Crown gas station (shown here), which was located on the southwest corner of Sierra Highway and Palmdale Boulevard from 1930 to 1946. He also held a government mail contract on Star Route 1, which went from Palmdale to Littlerock, Pearblossom, Juniper Hills, Llano, and Valyermo. Like his father, Owen became integrated into the community, as he was president of the Palmdale School District, the Palmdale Chamber of Commerce, and the Kiwanis, a founder of the Fin-and-Feather Club, and a volunteer fireman. He is the only second-generation president-member of the Palmdale Irrigation District. Three generations of Moultons have attended Antelope Valley High School. Like many of the valley's early high school students, because of the distance to school, Edwards's daughter-in-law Cora Moulton stayed during the week at the school's dormitory and returned home on the weekend. Many of the early Moultons are buried in the old Palmdale Cemetery. Edward's great-granddaughter Connie pays homage to her family by displaying a small section of a sales case from the family's hardware store in her dining room, showcasing Zada's antique dishes. (Courtesy of the Moulton and Guenther families.)

Cora Guenther Moulton

Owen Moulton Sr. married Cora Guenther (1907–1986), whose parents, August Guenther (1880–1949) and Hannah Lecher (1886–1968), came to California in 1914 and homesteaded in Valyermo, where St. Andrew's Abbey is now located. Like others before him—and continuing today—August had been told to move to a drier climate because of his severe asthma. Although 1914 may seem a relatively modern period, even at this time, Hannah was a true frontier woman. She used wood for cooking and heated water for baths and to wash clothes. The family had no electricity, only candles or oil lamps. Their water was brought up from Pallet Creek. Life became easier when they moved to Palmdale in 1929. For 34 years, August was employed by the Los Angeles County Road Department. He was liked by all who knew him and would do anything for anyone. Cora was also a community-minded citizen. She was a member of the Palmdale Emblem Club and the Palmdale Woman's Club, participated in the Palmdale Cemetery's fence project, worked the election board for many years, and helped others to improve their reading skills in the Antelope Valley Adult Literacy Program. She would assist anyone who needed transportation to doctors or shopping. She canned pears and peaches and made pies not only for her family but for people who lived alone. As the Moultons lived near the railroad tracks, many hobos came to their door asking for food, and she never turned them down. She was a member of the Gray Ladies, a group similar to the Red Cross. In this photograph, Cora (right) and Palmdale resident Angie Valdez are shown wearing their Gray Ladies uniforms during the 1950s. In 1952, as a Gray Lady, Cora assisted in helping victims of the destructive Tehachapi earthquake. She was also the recipient of the South Antelope Valley Coordinating Council's Outstanding Community Service Award for 1976–1977. (Courtesy of the Moulton and Guenther families.)

Rancho Raviri

Located in Quartz Hill, Rancho Raviri is a world-famous almond confections store founded in 1952 by two friends, Gael "Don" Raven (1920–2004) and Walter Biri (1914–1994). "Raviri" is a combination of their last names. When Rancho Raviri opened, more than 2,000 acres of almond trees were being grown locally. Although Raven and Biri knew nothing about almonds, they soon became known as "the Almond Kings." They eventually sold the business, and subsequent owners continued the almond confection tradition in the Antelope Valley. One owner was musician Chris Hingley (?–2006), a former newspaper librarian who purchased the business in 1992. Lee Baron (shown here) acquired the business in 2008 and moved it to its current location on Fiftieth Street West. Following the store's 60-year delicious tradition, Baron has been called "the man who saved Rancho Raviri."

Frank Rottman

As Nebraska was too expensive for them to own a home, Frank Rottman's parents, Gustave and Bertha, and their eight children moved to the valley in 1911. The family settled at Ninetieth Street West and Avenue A on 320 acres. At 16, Frank (1909–1989) dropped out of Antelope Valley Joint Union High School, due to the hard work required in running the family's alfalfa ranch. In 1928, Frank started Rottman Well Drilling. He had his brothers help him, but as the business was initially not profitable, they had to take on odd jobs, such as working at the Burton Brothers Mine at Tropico. During this trying period, they often slept in the fields to avoid the bill collectors who were looking for them. The hard drilling work was continuous, and there was no off-season. The primary operations of the company at that time were drilling and equipping agricultural water wells around the valley and other parts of Southern California. By the 1940s, the business expanded into the domestic and industrial fields. In 1943, Rottman married Elfriede Breiholz, whose family lived on the east side. They met when Frank was drilling a well on her family's property, which was followed by a Tehachapi apple pie baked by Elfriede. In 1946, the family moved to Elm and Newgrove Streets; Elfriede still resides there. The business improved, and Rottman established a Lancaster office on Avenue I in the early 1950s. Frank was also a member of the Desert Marksmen Rifle and Pistol Club and became a trapshooting champion; he qualified as a trapshooter for the Moscow Olympics. Frank's son Larry, who made well-digging toys when he was three years old, was born into the business. Larry started working for his father in 1962. He worked on larger business ventures, such as the Lancaster Prison. He became the owner and chief executive officer of Rottman Drilling Company in 1975. Now, Larry's son Matt is getting ready to begin the company's third generation. Rottman Drilling Company employees from left to right are Leroy Jones, Bill Boughan, and an unidentified worker. (Courtesy of the Rottman family and Rottman Drilling Company.)

Francis "Frank" Sperling

Sperlings Furniture has operated in Palmdale since 1964. Raised during the Depression in North Dakota, Frank Sperling (1932–present) came to California in 1955 when his sister Audrey, who lived in Lancaster, told him that a Los Angeles doctor could help him with his hearing problems—and he did. He remained in the valley and became a truck loader for McMahan's Furniture in Lancaster. He worked his way up and was promoted to manager. After he married his wife, Renee, in 1959, Sperling and a partner purchased a bankrupt furniture store on Sixth Street East near Avenue Q. When the partnership ended, Sperling expanded his business in 1970 and had a store built at its current site, Third Street East and Palmdale Boulevard, and named it Sperlings Furniture Store. The Sperlings' son Kevin (left) and Renee also work in the store.

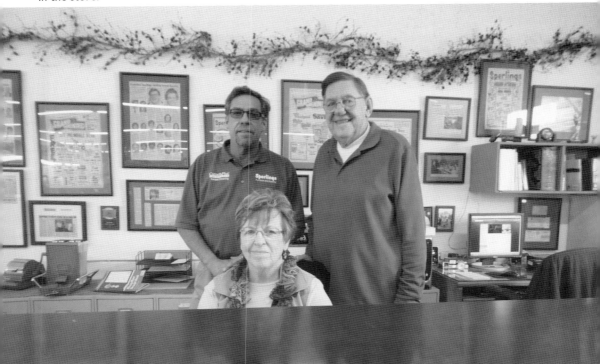

INDEX

LEGENDARY
LOCALS

AN IMPRINT OF ARCADIA PUBLISHING

Find more books like this at
www.legendarylocals.com

Discover more local and regional history books at
www.arcadiapublishing.com